the
art
of
Calligraphy

By the same Author

Better Handwriting	1954	Penguin / Puffin
Traditional Scottish Recipes	1975	Canongate
The New Better Handwriting	1977	Canongate / Pentalic
Scribe	1978	Canongate / Pentalic / Taplinger
Christmas Recipes	1980	Canongate
Traditional Irish Recipes	1982	Canongate / O'Brien / Pelican
Rubber Stamps: how to make them	1982	Canongate / Pantheon / Random House
Dear Sir	1984	Thorsons

the art of Calligraphy

George L. Thomson

❖

Treasure Press

First published in Great Britain in 1985 by
Thorsons Publishers Ltd. under the title
The Calligraphy Work Book.

This edition published in 1986 by
Treasure Press
Michelin House
81 Fulham Road
London SW3 6RB

Reprinted 1986, 1989, 1990, 1991, 1992, 1993

© George L. Thomson 1985

Front cover illustration:
British Library

Title page illustration:
The Fotomas Index Library

ISBN 1 85051 156 X
Printed in Hong Kong

Introduction

The four alphabets presented here are designed to be examples typical of specific FAMILIES of scripts, but also legible and easy to learn and write. They have been modified where necessary to make certain letters intelligible to modern eyes.

The Black Letter capitals particularly have been rationalised and made recognisable. While we agree that the various versions of capitals in many Gothic scripts can be beautiful examples of abstract decoration, no one today would claim that they are LEGIBLE. For anyone who would wish to go on eventually to write the more exotic black letter scripts, the mastery of the very simple version here shown will provide a working knowledge of the disciplines required. Though it may look quite complicated to the layman, the letters need no more strokes than any other script.

Those who are interested in RVSTIC script may wonder why it is not included here. In our opinion, it is one of the worst scripts ever invented - illegible, badly proportioned, uneven in colour owing to the exaggerated pen angle. It may be that it looks so inept even when written by a master scribe that the

efforts of a beginner can be a near approximation, thus giving him a false estimation of his own abilities. Admittedly it is historically important, so leave it to the paleographers!

The Round Hand version given here is of the same family as Carolingian, Humanistic and Edward Johnston's Foundational Hand. Again, to simplify things for the learner, where there are alternative forms of particular letters, we have chosen only one. It is a simple matter to change to a preferred form AFTER the script is mastered. These remarks also apply to the Italic script recommended here. Note here that ascenders and descenders may be made as long as the scribe wishes, providing the space between the lines is proportionately increased. Bear in mind, however, that the longer they become, the more difficult it is to keep them of even length and slant. Slight discrepancies which would not be noticed in normal writing will be glaringly obvious on letters of exaggerated length.

We have emphasised the necessity of keeping the same angle of the pen's chisel edge. PEN ANGLE is invariable in the best scripts. Changing the angle at every stroke means pivoting the whole hand, and would result in an unacceptably slow writing speed. Even a master calligrapher would find it impossible to write fast enough to keep

the "flow" of the writing.

Some black letter scripts have square
bases to the upright strokes of the
letters, but we do not recommend this
to any but the most advanced students.
These should keep the pen angle constant
to the foot of the stroke, ▮ ▮ filling
in the square base or slight serif with
the left corner of the nib point.
Changing the angle to finish horizon-
tally, besides being fiendishly
difficult, results in a clumsy, heavy
looking letter, the vertical strokes
shading from narrow to thick.

while it may be agreed that these four
scripts are representative of the main
families of scripts, some may wonder
why there is no mention of Trajan
Roman, the ancestor of all. The
answer is that here we are dealing
purely with pen formed characters,
and it is generally accepted that
Classic Roman capitals were drawn
with the brush. For those interested,
there are some excellent books dealing
solely with Roman lettering.

A word about the spacing of letters. This
cannot be done mechanically. There
should be an optical balance of the area
of space on each side of a letter. To assess
your own spacing, look at each group of
three letters in the word, and it will be
obvious when one pair of letters appears
either cramped or too far apart.

As a general rule, O's should be close
to each other, OI slightly further apart,

and 11 further still. The diagram
below illustrates what we mean.

VOOIIAV

While this applies to all lettering, it
is most important in words written in
capitals only. For the best results,
always do a preliminary rough layout.

Four Easy Scripts

The student calligrapher will find here the four main scripts from which all the others are derived; uncial, round hand, black letter and italic.

Each one is reduced to the simplest possible forms, with a few modifications here and there to bring them into line with modern usage.

These basic shapes can be built upon as a completely reliable base as the student progresses, perhaps to study under a professional scribe; but they can stand on their own merits for busy people who simply want an easily written script for occasional use.

The minimum of equipment required is: ink, pens, paper, a board, T-square and set-squares, and compasses and dividers. Few crafts need less working tools.

The cheapest ink you can get will serve while you are practising, but for finished work you must have a good black ink. This may be waterproof or non-waterproof. For coloured lettering, use diluted poster colour rather than inks.

William Mitchell's Pedigree Round Hand Pens can be bought as a set, with a holder, on a card. Osmiroid and Platignum make useful fountain pen lettering sets. For very large lettering you may eventually want to buy witch or poster

pens. It is not too difficult to make
your own pens from twigs or bamboo.
Any smooth white paper will do for practice,
but for better work, get something more
substantial. Notices and labels will
quite often require stiff card.
Any board big enough to hold your paper
will do. It should be propped up at an
angle. Professional scribes may prefer
an angle of 45° or so, but you will
probably be more comfortable with something
less steep.
Use the T-square and set-squares to line off
your paper, measuring the height of your
lettering in pen-widths. Hold the pen
sideways. The height will vary according
to the size of the nib you are using.
Pin one or two sheets of paper on the board,

big enough to cover it. This provides a
resilient backing for the writing sheet,
and makes for more comfortable writing.
Fold a piece of paper about 6" wide and
pin across the board about two thirds
of the way up. Your writing sheet
goes under this, and is held without
pinning, so that it can be moved up, a
line at a time, to the proper height.
This also helps to keep it clean.
Your pen may be dipped in the ink for
practice work, but keep a cloth handy
to wipe the back of the nib. For really
fine writing, fill the nib from the front
with a brush, so that no ink gets on
the back at all. This is necessary to
preserve the sharpness of the thin strokes.
Do not practise for so long that you become

bored. Stop! because then you can go on
repeating a mistake without noticing
it. Calligraphy should be enjoyable,
and should look as though it had been
done with pleasure.
When you can write a script passably, look
for opportunities to USE it. Find someone
who needs a poster, a notice, even a label,
and do it without charge. You may not
be satisfied with your layout or writing,
but the chance to do a real job is of great
value, and the more experience you get,
the more confidence you will have.
If you can achieve complete command of
these four scripts, you will be well on
the way to becoming the Complete Calligrapher.
But you will never arrive! The more aware
you become of perfection, the less likely

it seems of achievement. And this is
the charm of genuine calligraphy. Even
the very best has little flaws and
imperfections to remind us that the most
polished and assured scribe is still only
human, and that this was the work of a
fallible human hand. If you want
every letter to be identical every time, then
you must turn to the machine, to the
printing press, or to the typewriter. But
that way you can never feel the inner
glow of pride and satisfaction which comes
from the completion of a not quite perfect
piece of lettering which is all your own
from start to finish.
Before using a broad pen for the first time,
teach your hand the rhythms of broad
pen writing by practising the three

movements shown in the diagram overleaf.
Cut a piece of stiff card to represent the pen
made large, and hold it by the sides so
that the chisel edge tip lies flat on the paper.
Follow each stroke in proper order, but
the very first rule is that the EDGE
must always remain parallel with the
dotted lines, no matter whether the
direction of the stroke is a curve or a
straight line.

Use as little pressure as possible. The card
tip, and the pen tip when you come to
use it, should only touch the paper. It
should glide over the surface, not
plough into it.

Each script has a preliminary practice
diagram which incorporates all the
strokes used in that script.

The drawing shows the relaxed pen grip.
Never hold the pen tightly, with the
fist clenched. The angle shown is an
approximation. Experiment until you
find one which allows you to follow the
diagrams without strain. The pen edge
itself will guide you; if it runs smoothly,
you are doing it right, if it digs in or
skids, you are doing it wrong.

To start with, it is best to move the pen
quite slowly, but as your hand becomes
accustomed to the new rules, you will
write with confidence and more quickly.

For the sake of simplicity, only one form of
letter is shown in each script, though
there are many variations.

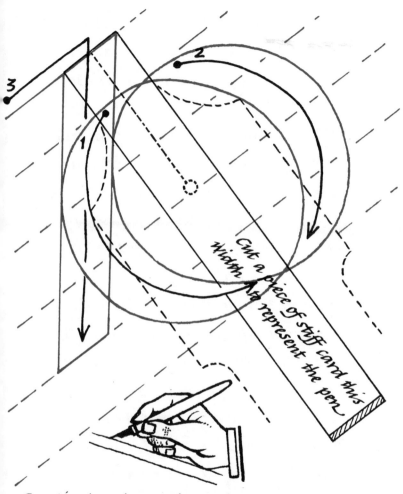

Cut a piece of stiff card this width to represent the pen

Practise these three strokes until you can keep the pen tip always parallel with the dotted red lines

Only four rules need be memorised

Keep your letters even in size. Keep the vertical letters upright, never slanting backwards. [In the case of italic, keep an even slant forwards.] Always have enough space between lines to prevent tangling of tops and tails. And finally, leave ample margins around the edges of each page.

Now you can start on the script of your choice, beginning with practice on the preliminary diagram.

Then, using your card strip, go over each letter in turn. Repeat each letter until you can write it automatically without having to check the order and starting place of each stroke.

Next, go over the small letters at the top of

the page in the same way, using a dry pen of the appropriate size. Keep your touch very light.

As soon as you have confidence, write with ink in your pen, copying under the small letters. Use a separate sheet of paper if you do not wish to write on the book itself.

Now try putting together words and sentences, keeping your letters closely spaced and even, leaving the space of an "o" between each word.

Each of the four scripts is what is known as a FORMAL script, but the italic can develop into an everyday cursive hand if it is written rapidly, with ligatures. In a formal script, the letters are not joined together.

At the end of each section is a selection of examples, illustrating some of the ways each script may be put to use.

The scripts are in chronological order. UNCIAL came from the Roman capital letter. ROUND HAND or Carolingian came later, and then BLACK LETTER, a compressed book hand. Last is ITALIC, which is also a compressed book hand, but much lighter and containing a more cursive element.

Formal scripts should be written with some care, but remember they can also be written fairly rapidly, because they were used for writing books before the invention of the printing press. Any scribe who took years to write and illuminate a single text [as the old myth claims] would very quickly

have found himself out of a job.

The beginner's two main difficulties are likely
to be, keeping the long strokes straight
and vertical [it is very easy to introduce
a backward slant], and keeping the
letters the same height throughout.

But never despair. As time goes by, the
things you found difficult will become
easy.

practise, practise, practise!

But now, you may be thinking, does
one make the thin vertical line? No,
not with a pointed pen. It is made by
turning the pen edge and sliding it sideways,
like the runner of a sledge.

Use it as a decorative "grace note" to embellish
capital letters only, never on minuscules –
[small letters.] Note the spelling, because
too many people are now using MINI-scule,
probably influenced by minicar and miniskirt!

uncial

Practise pen handling with the dummy
pen point before you attempt the letters.
Most letters can be written with only one
or two of the strokes in the diagram.
These large sweeping movements help to fix
the right movements and sequences in the
mind, and re-educate the writing muscles.
Use a light touch to counter the "death grip"
used by so many – the cause of writers' cramp.
It is most important to keep the writing edge
of your pen in contact with the paper all along
its width, AND at the same angle as the
dotted lines, no matter whether you are
making straight or curved lines. Beginners
often turn the wrist and the pen edge to follow
a curve. Resist the temptation to do this!

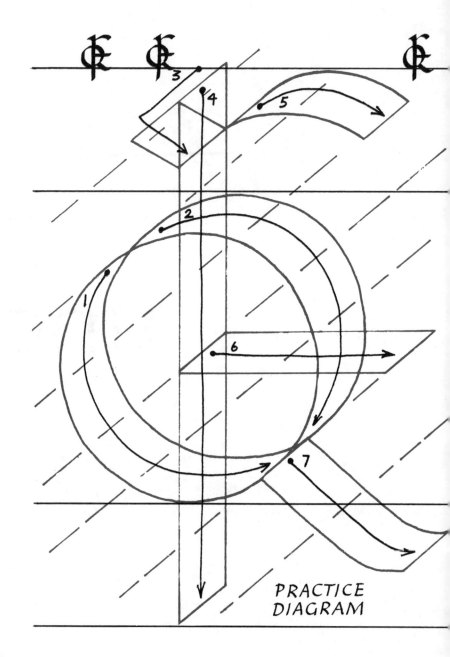

PRACTICE
DIAGRAM

a a a a a a a a b b b b b b

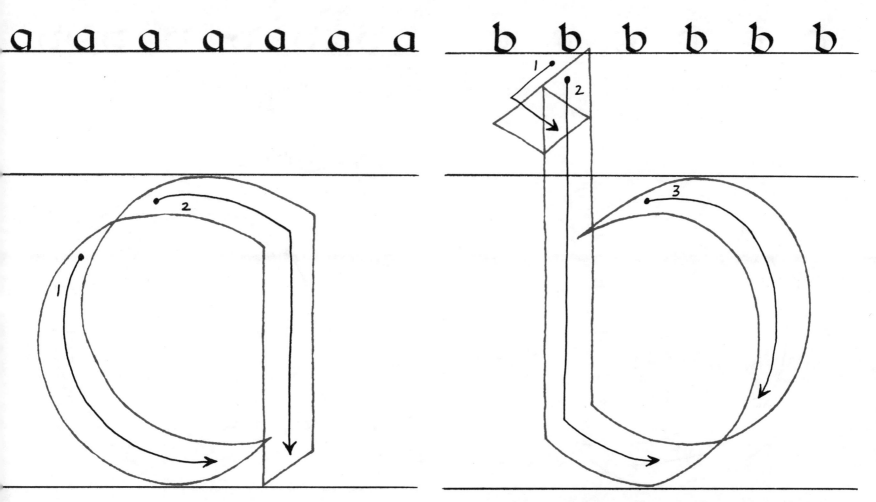

When necessary, make capitals by either writing
the letter bigger or by changing the colour

21

c c c c c c

d d d d d d

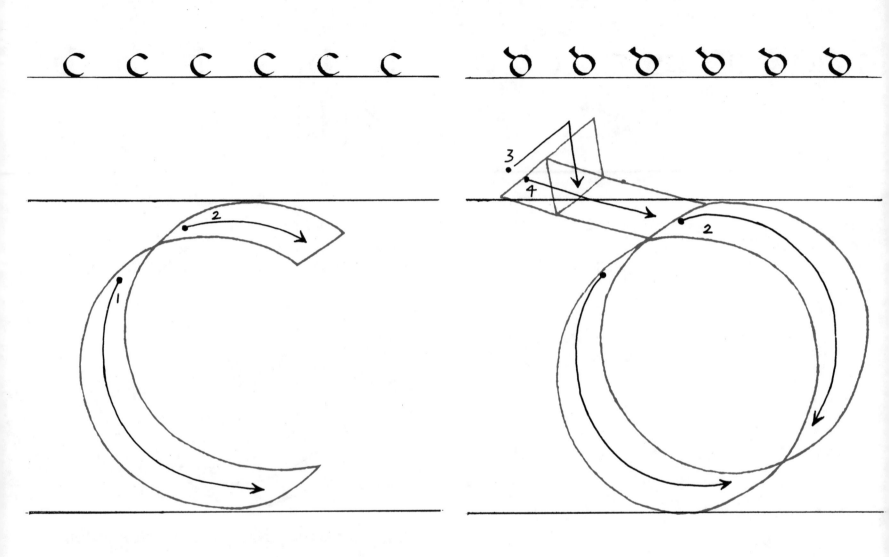

3
4
2

1

2

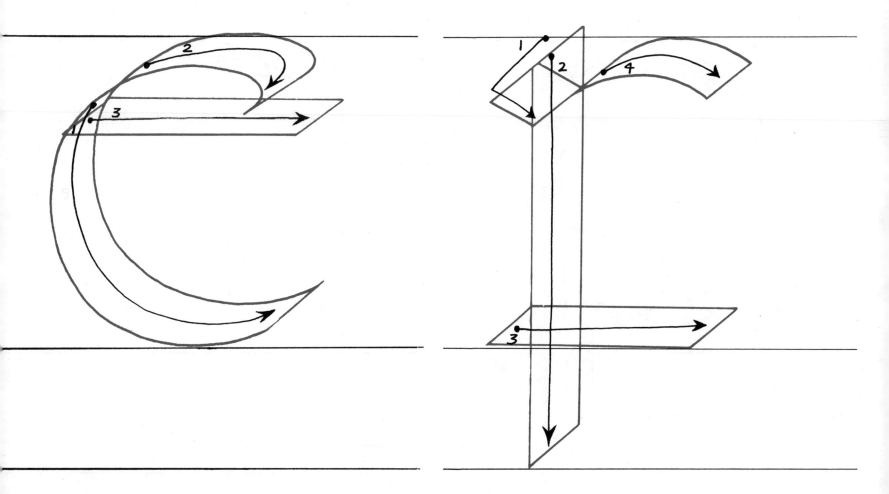

g g g g g g h h h h h

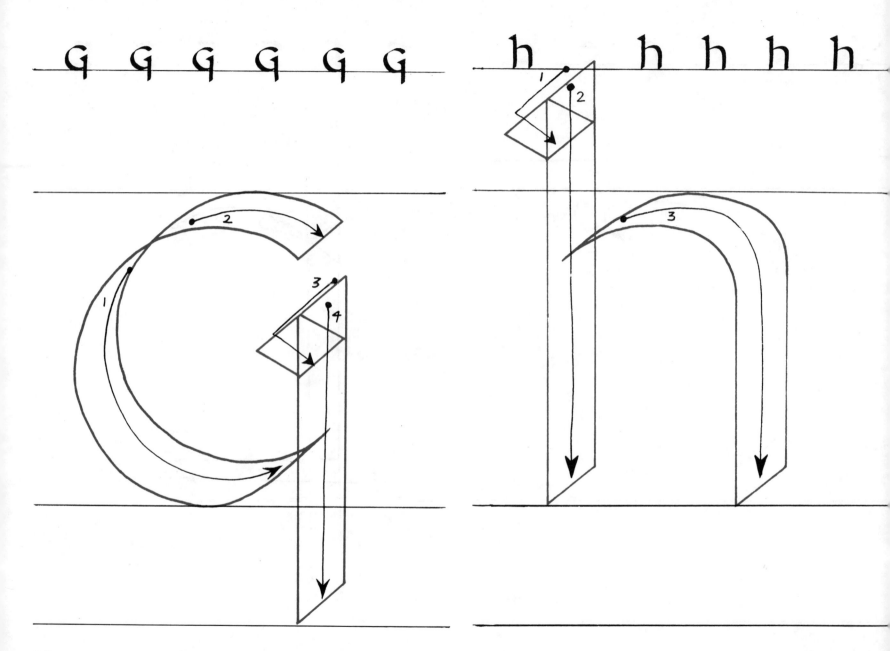

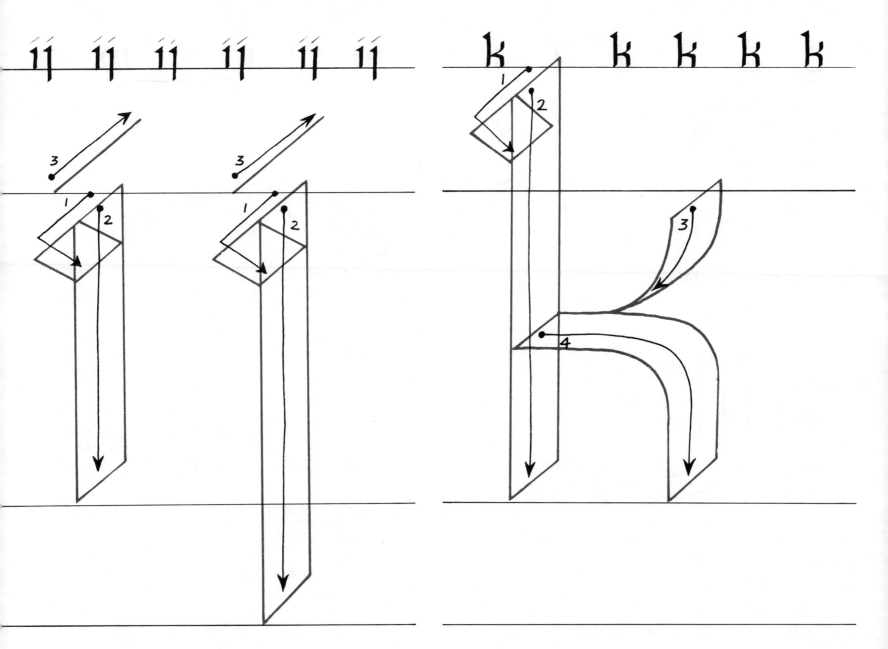

l l l l l l l m m m m m m

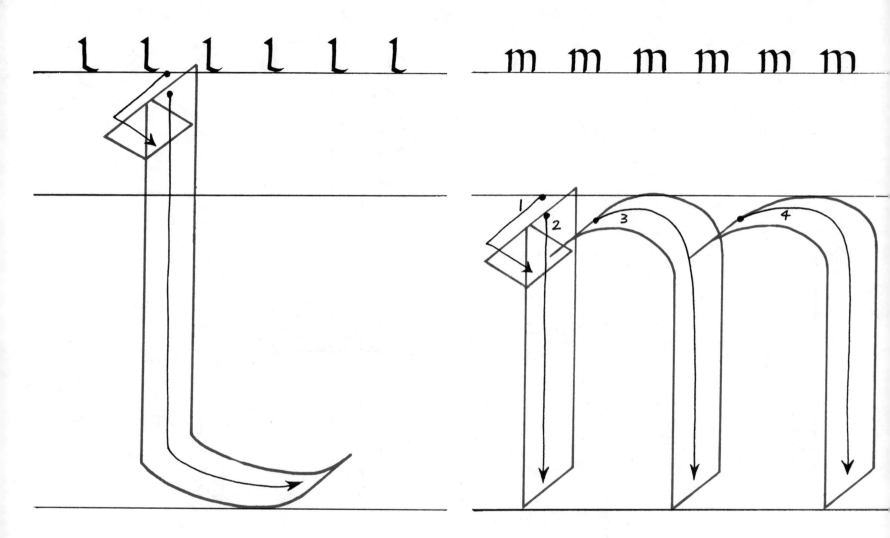

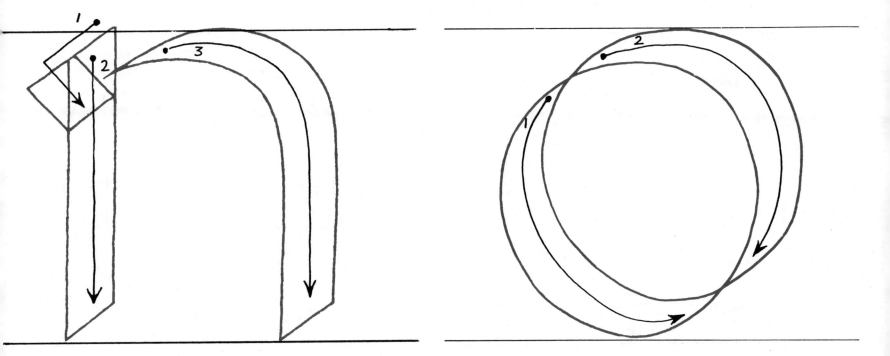

p p p p p p p Q Q Q Q Q Q

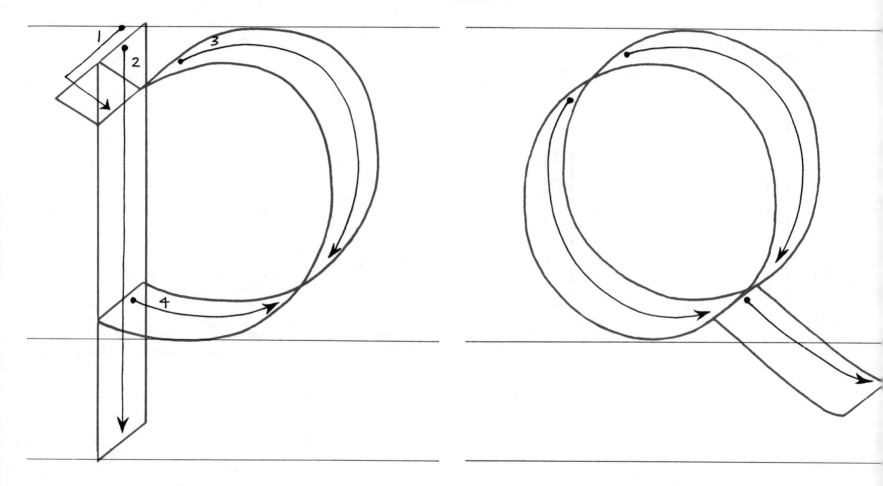

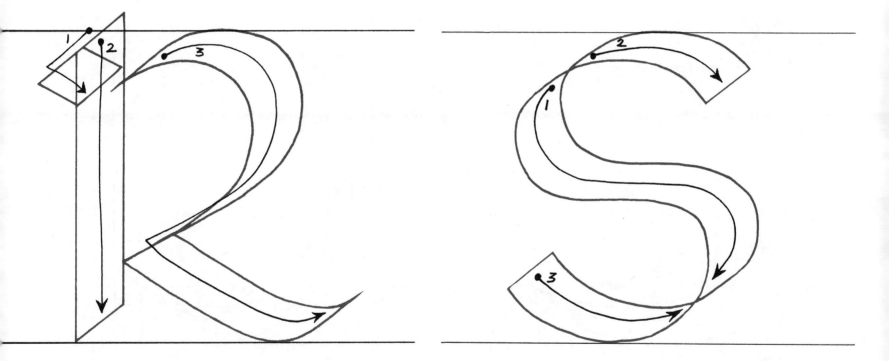

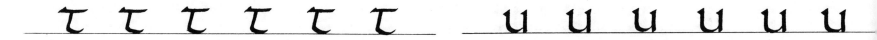

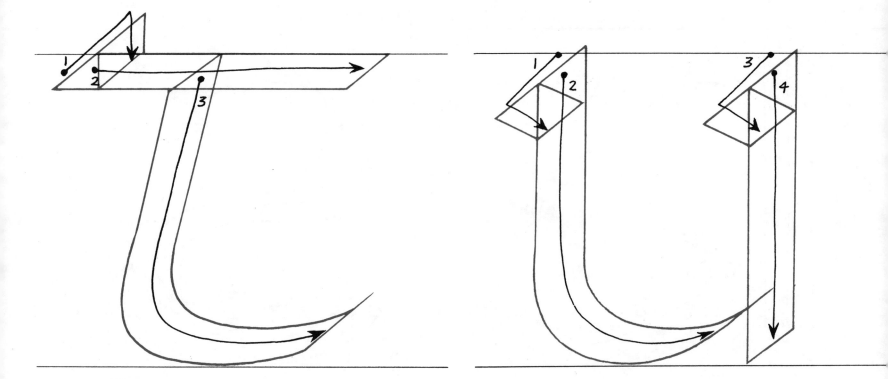

ν ν ν ν ν ν ɯ ɯ ɯ ɯ ɯ ɯ

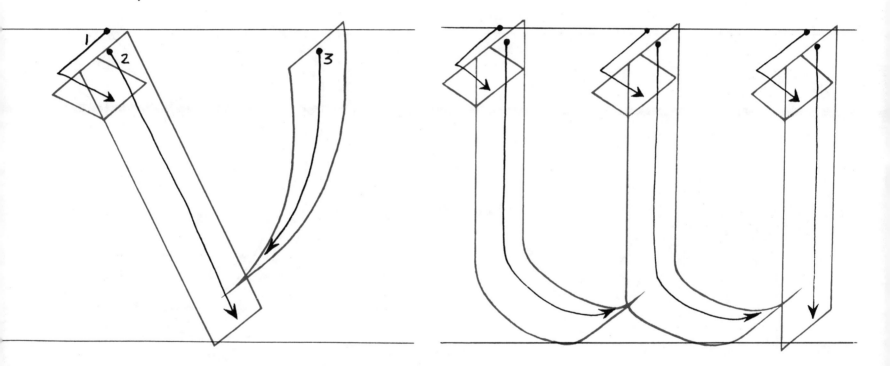

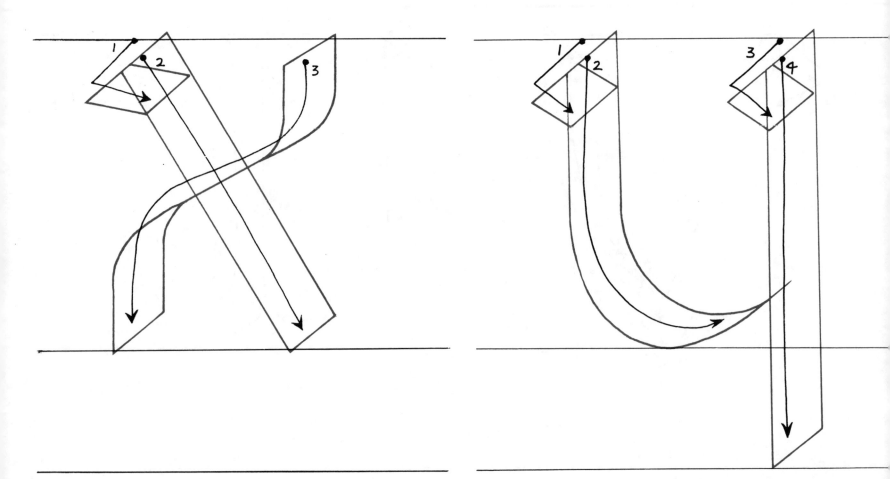

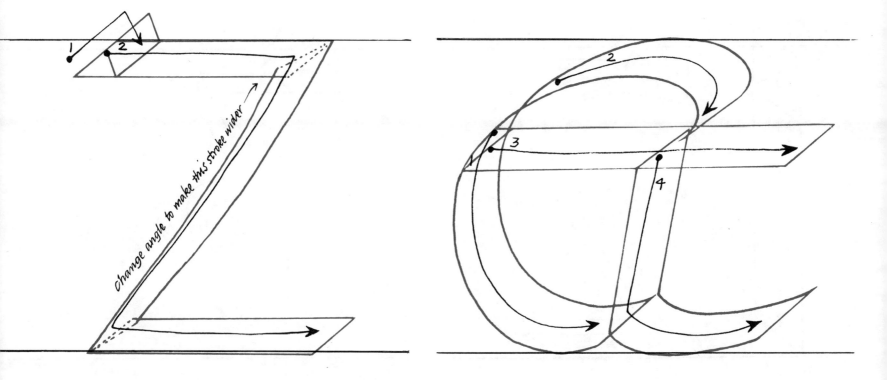

Change angle to make this stroke wider

33

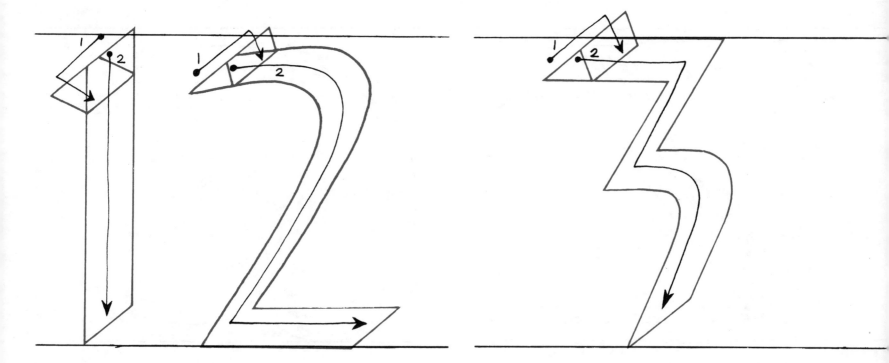

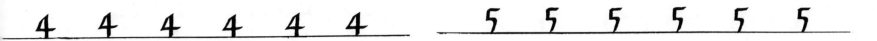

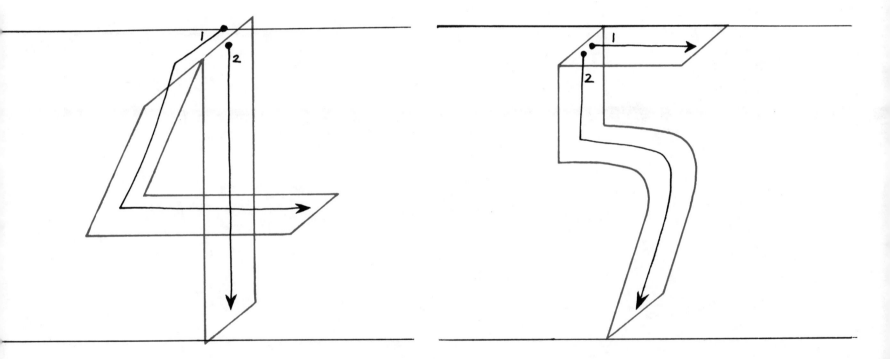

ƀ ƀ ƀ ƀ ƀ ƀ

7 7 7 7 7 7

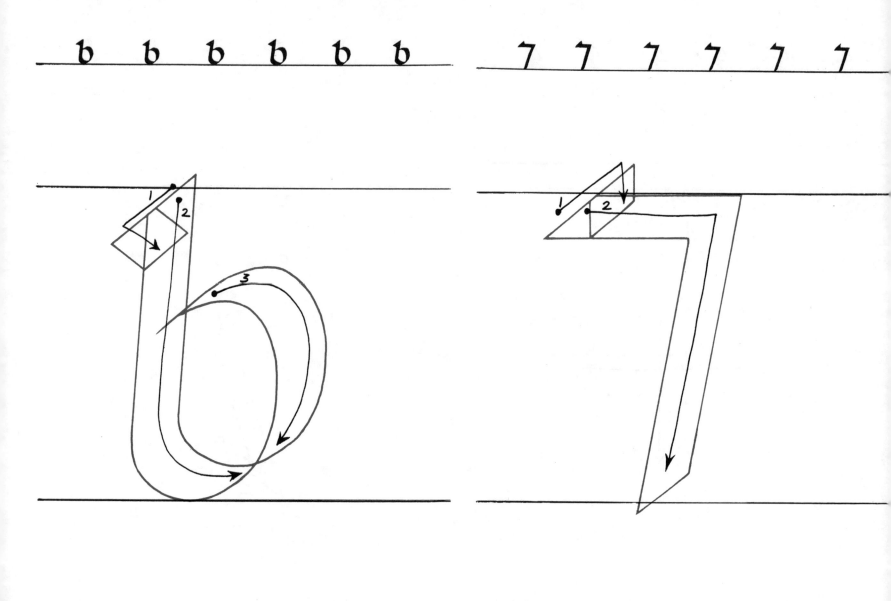

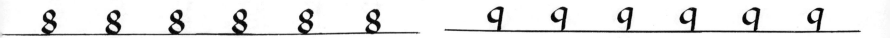

8 8 8 8 8 8 9 9 9 9 9 9

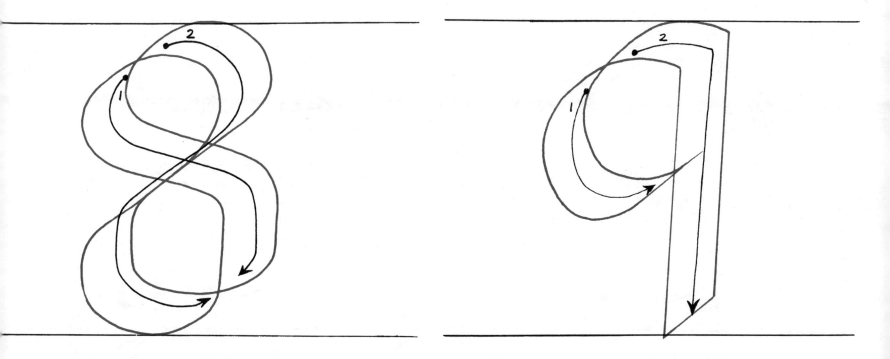

O O O O O O Ɛ Ɛ Ɛ Ɛ Ɛ Ɛ

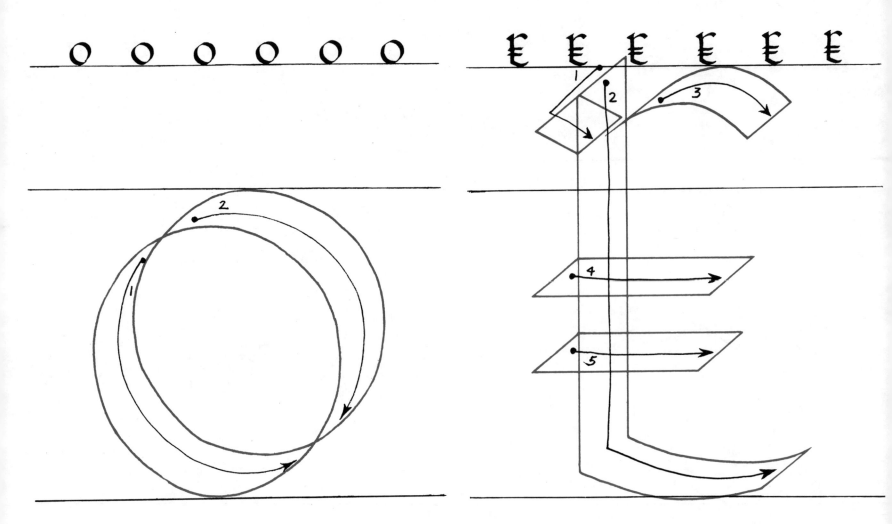

$ $ $ $ $ $ 17 17 17 17 17 17

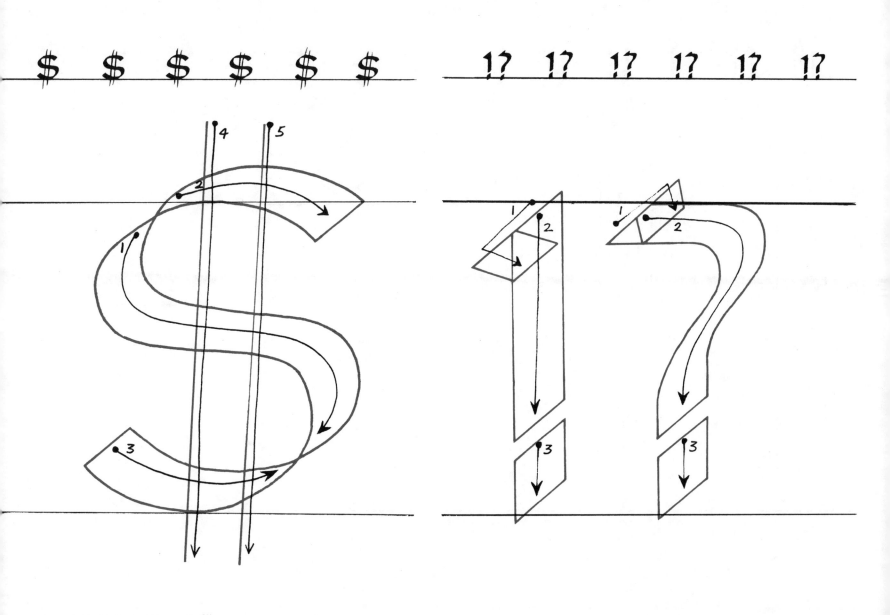

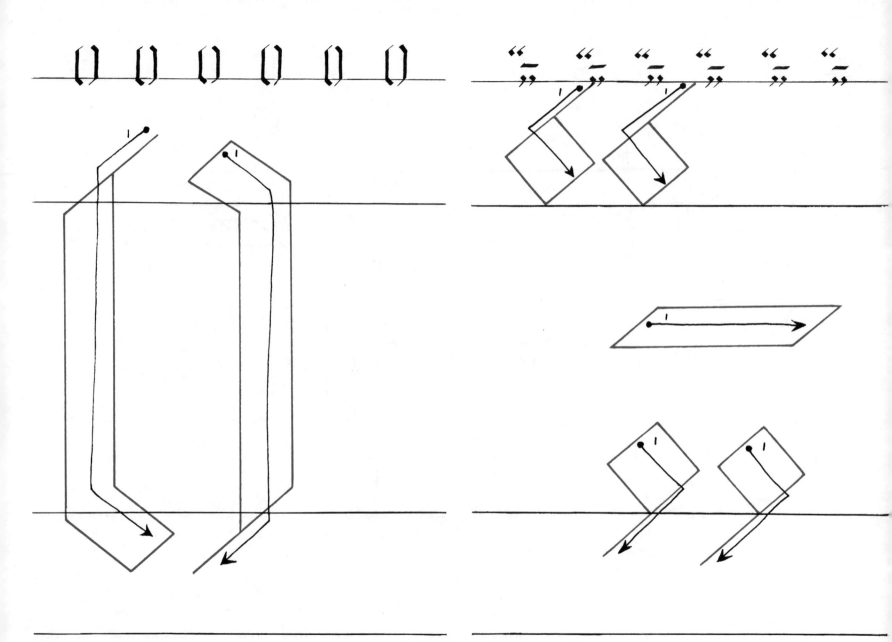

CELTIC ART

a series of lectures by
professor m.p. smythe

·

in
carnegie hall
7 pm fridays

✤

entrance free

Lub am faillean nuair
a tha e maoth

(Bend the sapling while it is young [Gaelic])

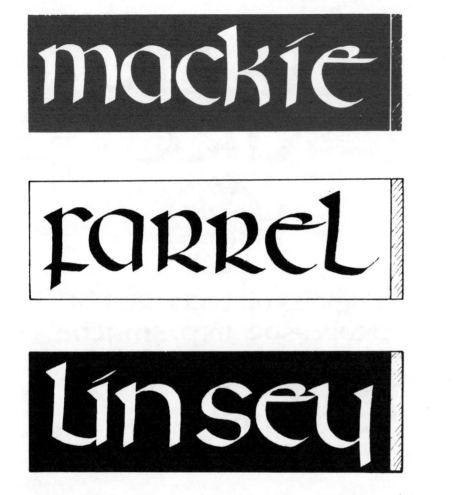

mackie

farrel

linsey

Name plates may be enlarged to any size you wish

weasel

basketry

biscuits

gallery

Ticket labels can be written on thin smooth card

42

round hand

Practise pen handling with the dummy pen point before you attempt the letters. Most letters can be written with only one or two of the strokes in the diagram. These large sweeping movements help to fix the right movements and sequences in the mind, and re-educate the writing muscles. Use a light touch to counter the "death grip" used by so many – the cause of writers' cramp. It is most important to keep the writing edge of your pen in contact with the paper all along its width, AND at the same angle as the dotted lines, no matter whether you are making straight or curved lines. Beginners often turn the wrist and the pen edge to follow a curve. Resist the temptation to do this!

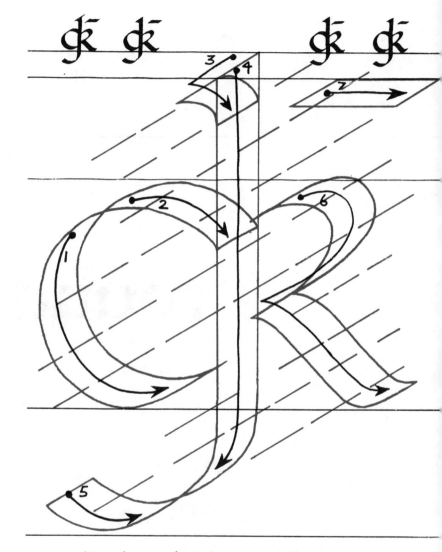

Keep the pen slant the same, whether you are doing vertical, horizontal or curved strokes

44

a a a a a a a b b b b b b

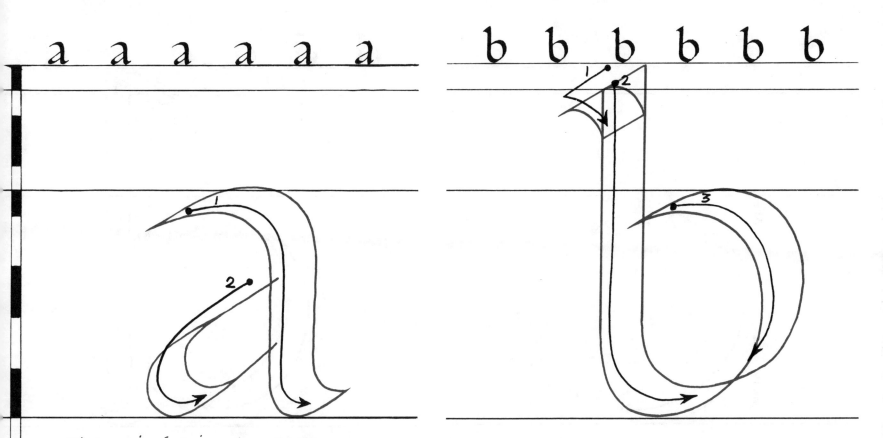

Whatever size of pen is used, small letters are
4½ penwidths high, capitals 6½, and tops
and tails 2½ above and below.

c c c c c c c

d d d d d d

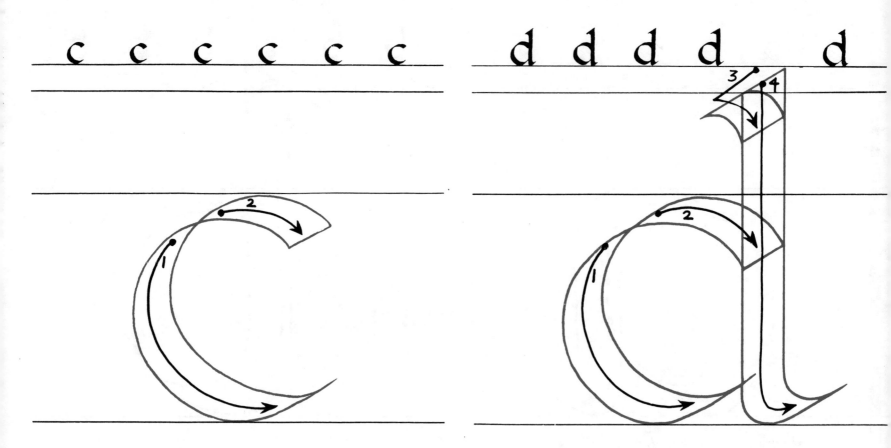

$e \quad e \quad e \quad e \quad e \quad e$ $f \quad f \quad f \quad f \quad f \quad f$

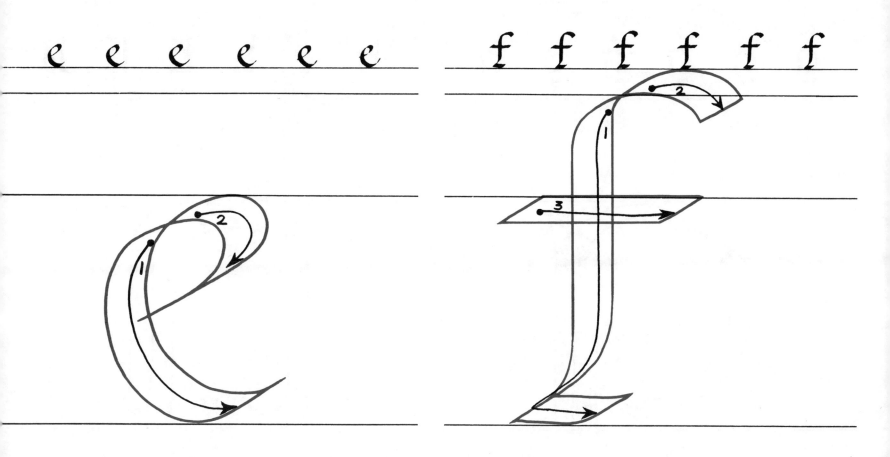

g g g g g g h h h h h

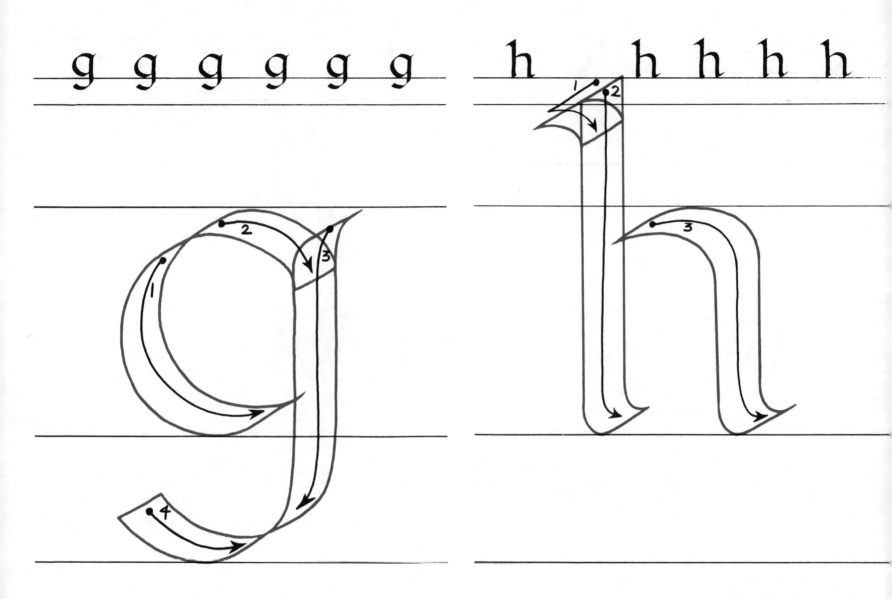

ij ij ij ij ij ij k k k k k

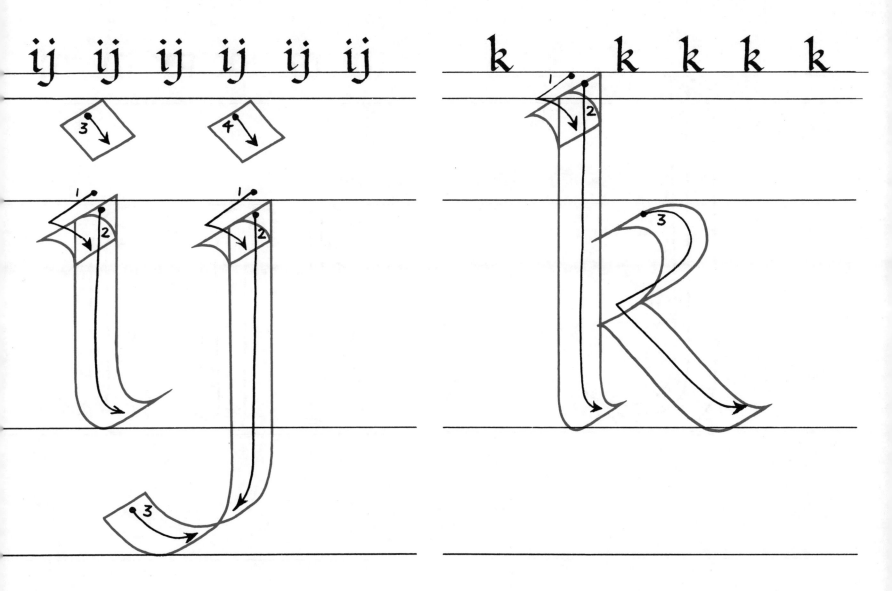

l l l l l l

m m m m m m

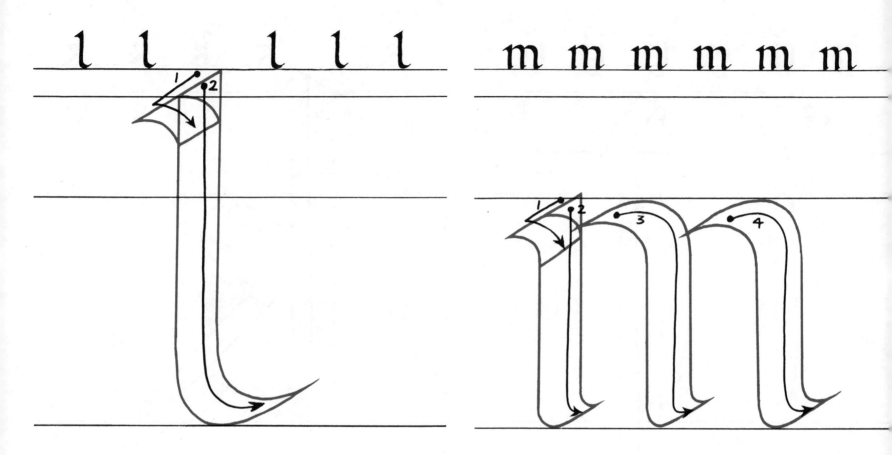

n n n n n n o o o o o o

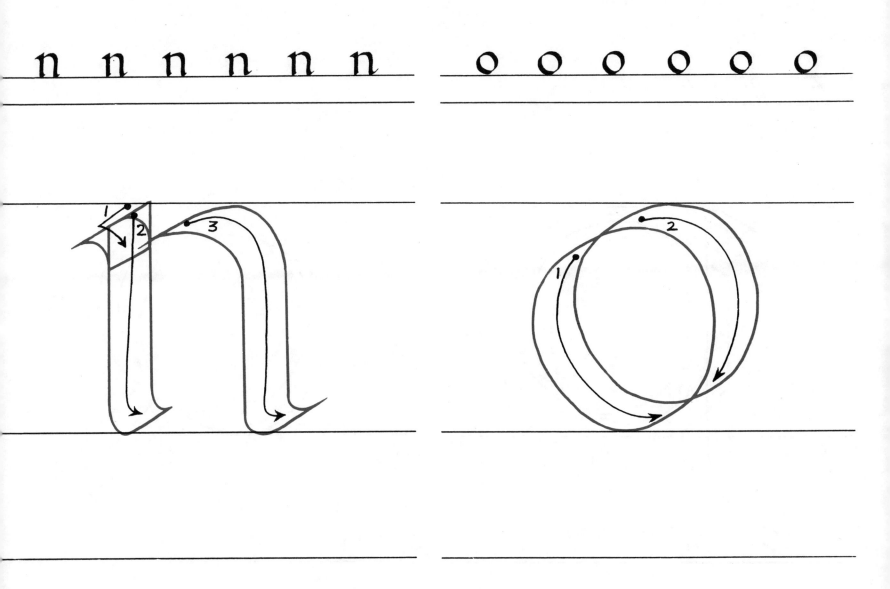

p p p p p p a a a a a a

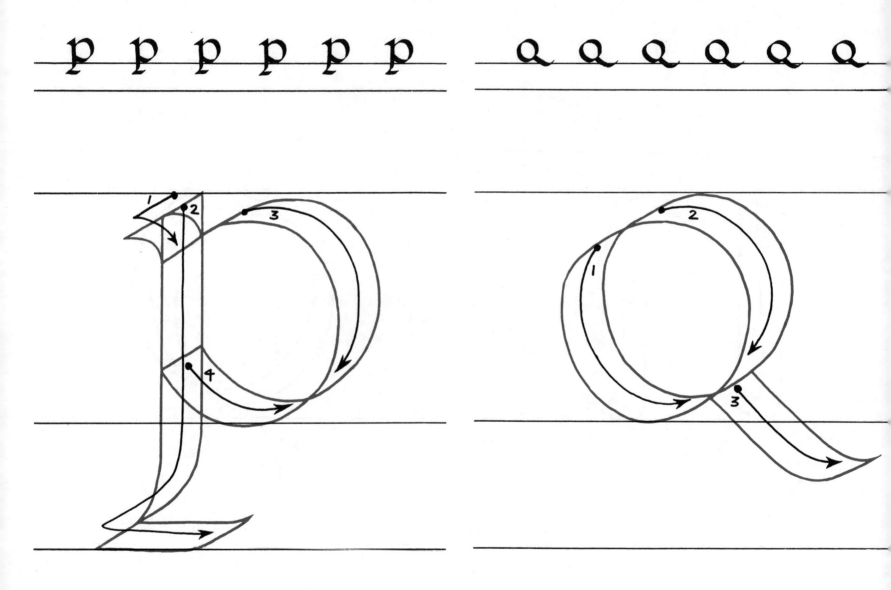

r r r r r r r s s s s s s

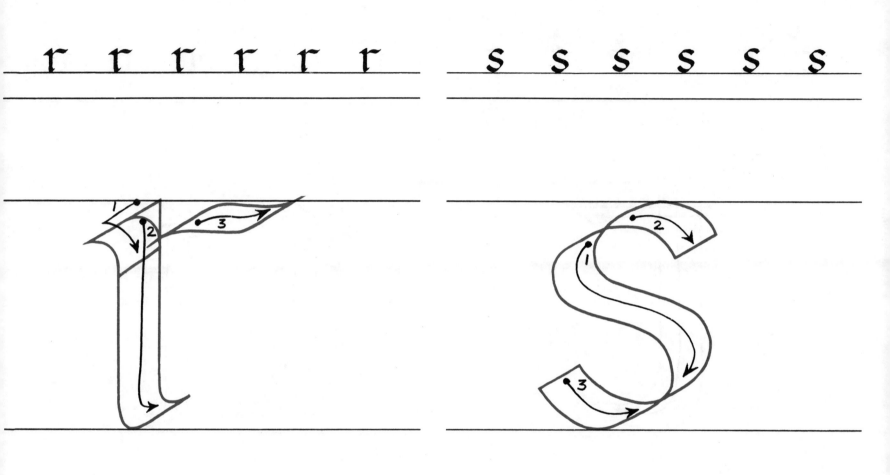

t t t t t t u u u u u u

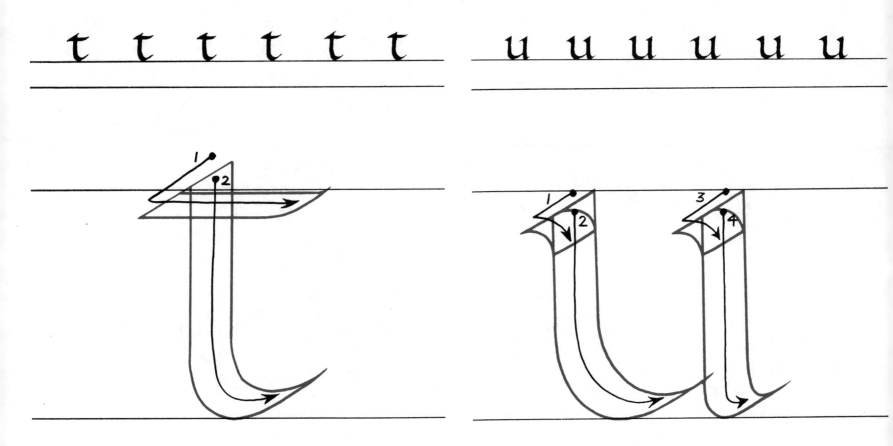

v v v v v v *ш ш ш ш ш ш*

x x x x x x *y y y y y y*

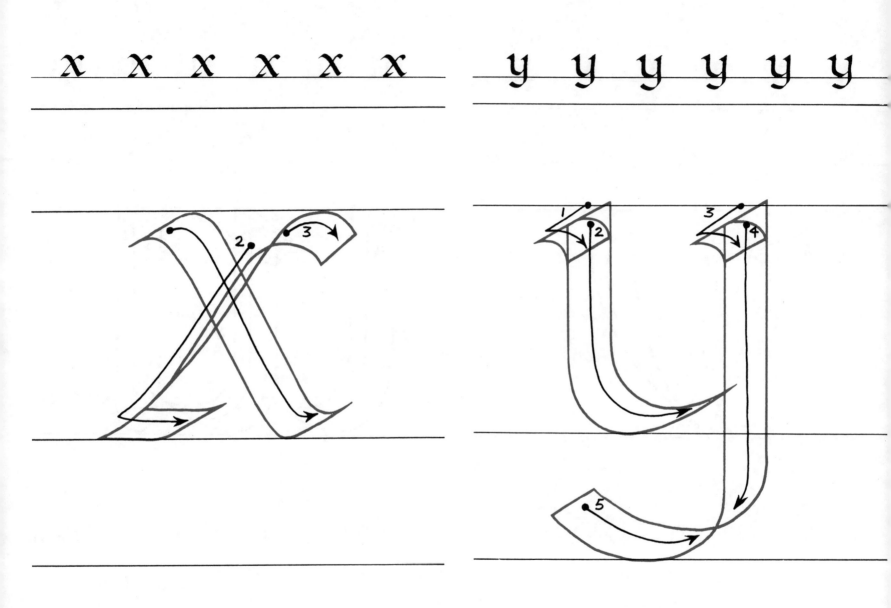

z z z z z z A A A A A

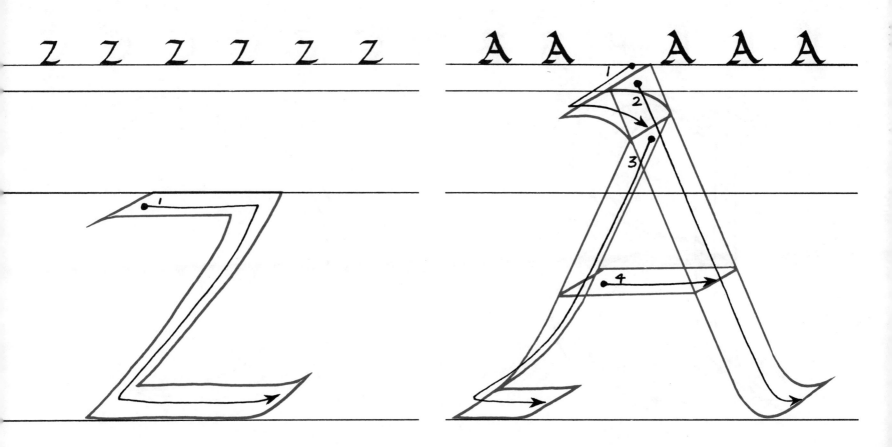

𝕭 𝕭 𝕭 𝕭 𝕭 𝕭 C C C C C C

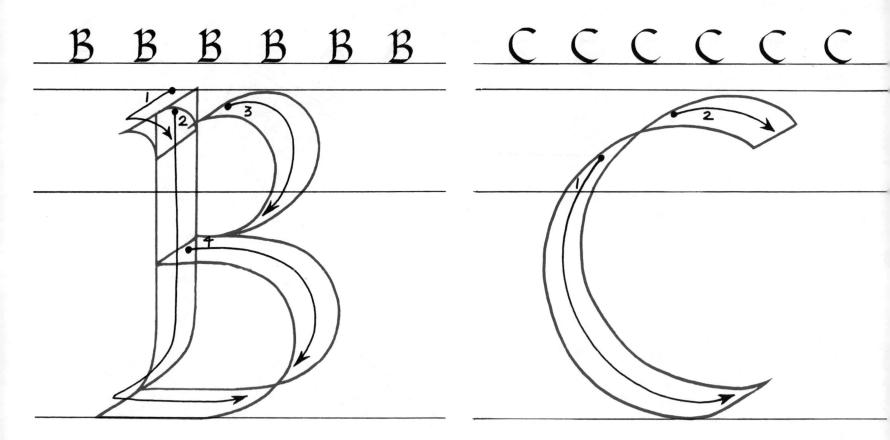

ꝺ ꝺ ꝺ ꝺ ꝺ ꝺ E E E E E E

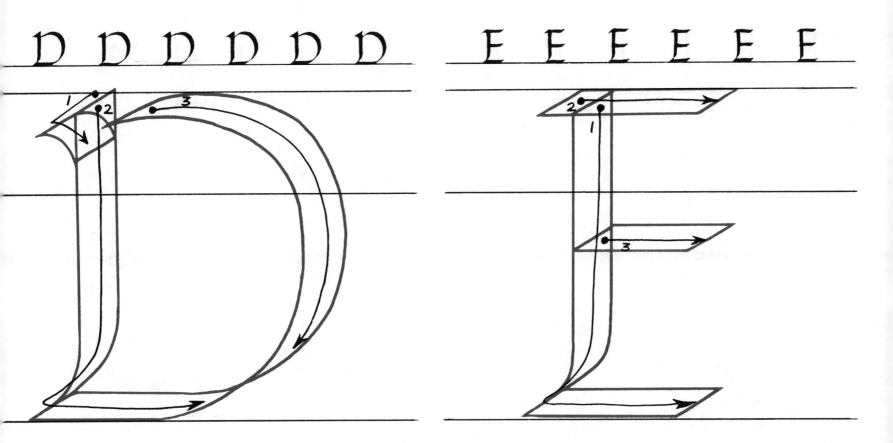

F F F F F F G G G G G G

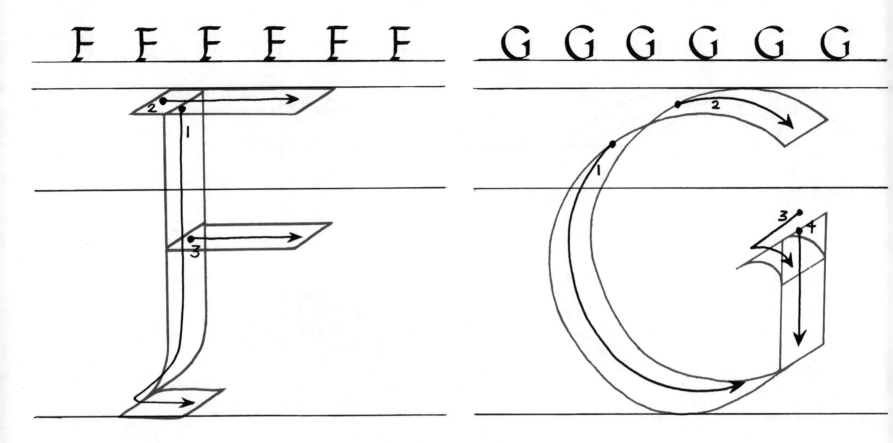

H H H H H H H IJ IJ IJ IJ IJ IJ

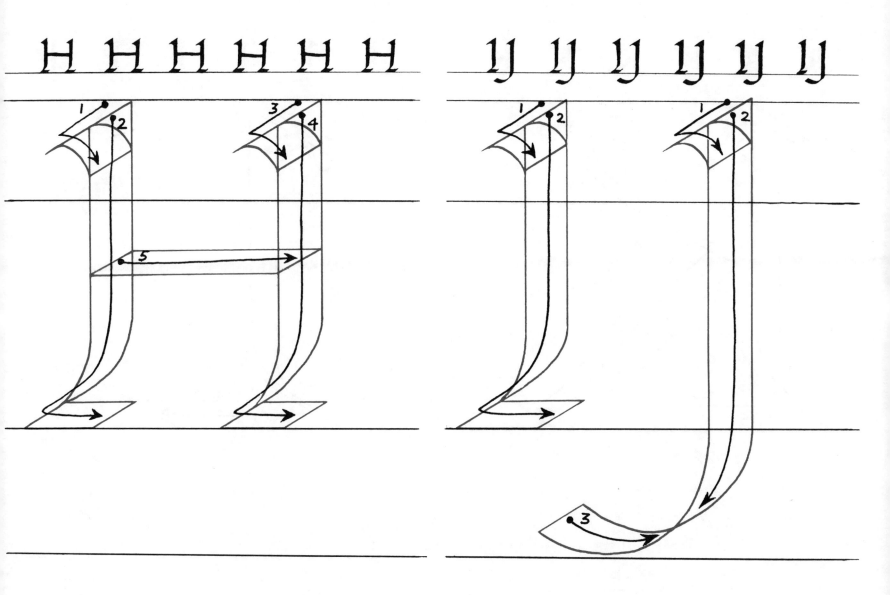

K K K K K K K L L L L L L L

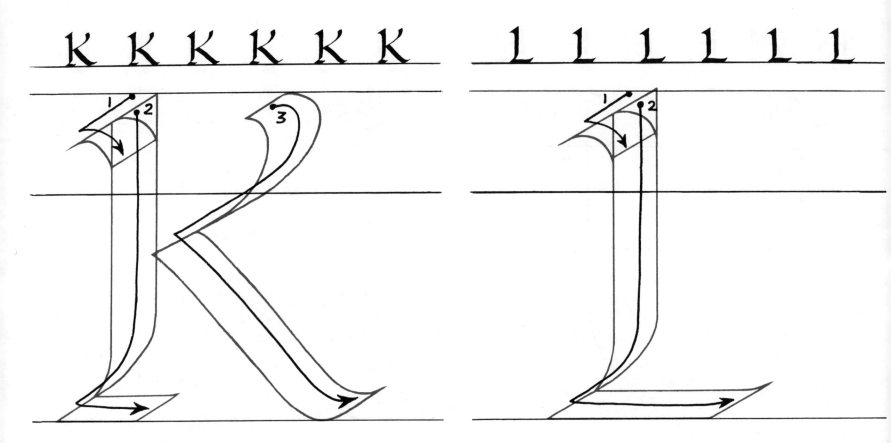

M M M M M M

N N N N N N

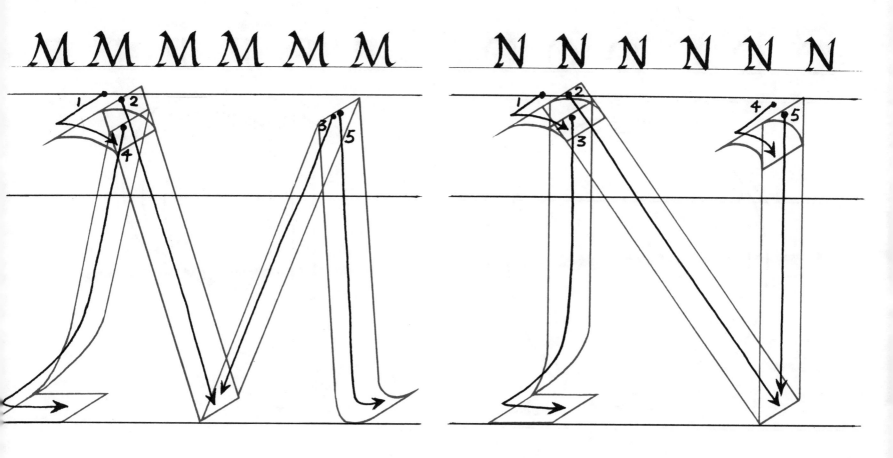

O O O O O O p p p p p p

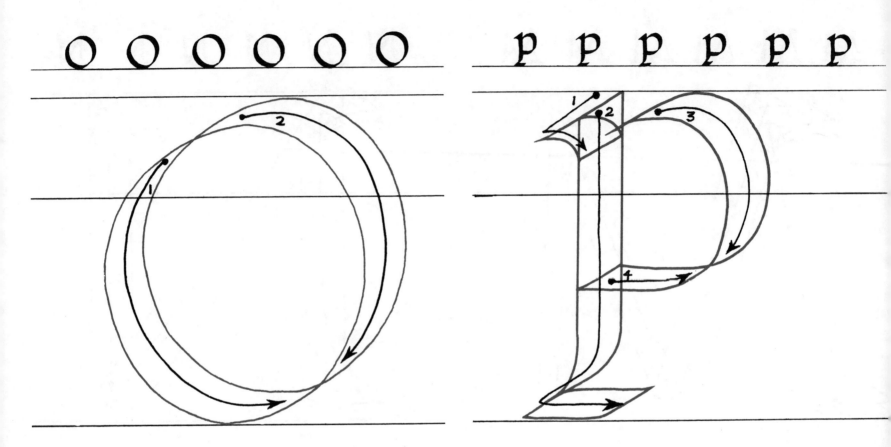

Q Q Q Q Q Q R R R R R R

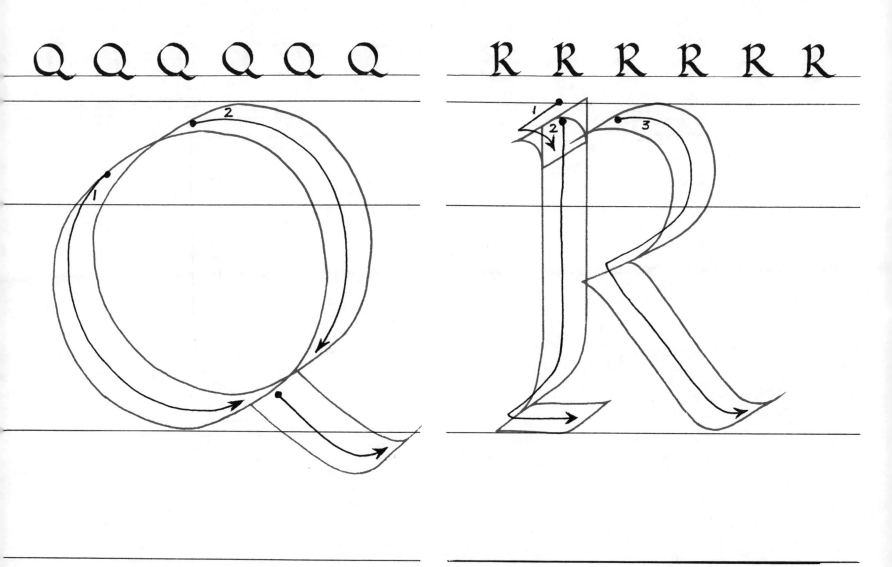

S S S S S S T T T T T T

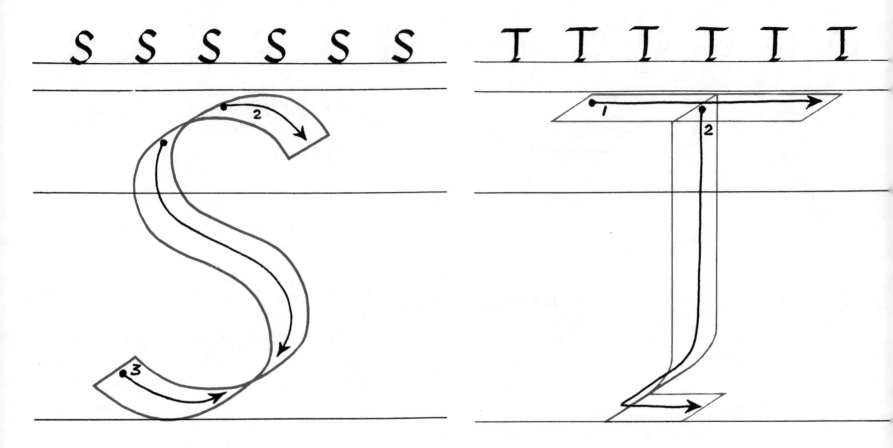

u u u u u u v v v v v v

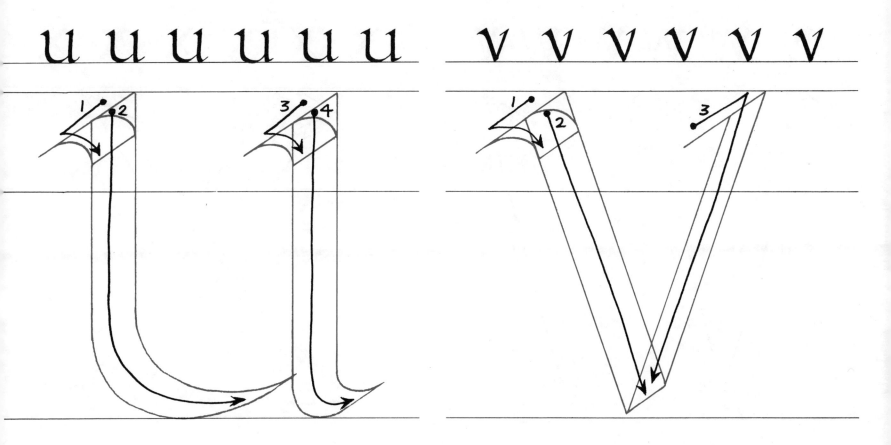

W W W W W W X X X X X X

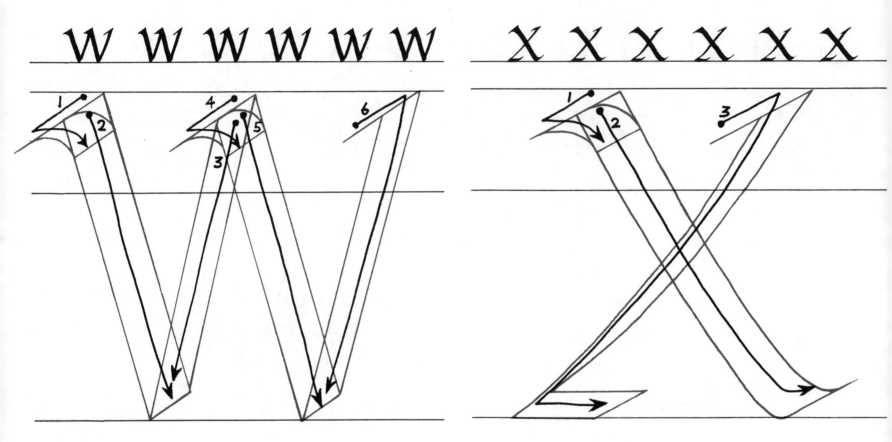

Y Y Y Y Y Y Y Z Z Z Z Z Z

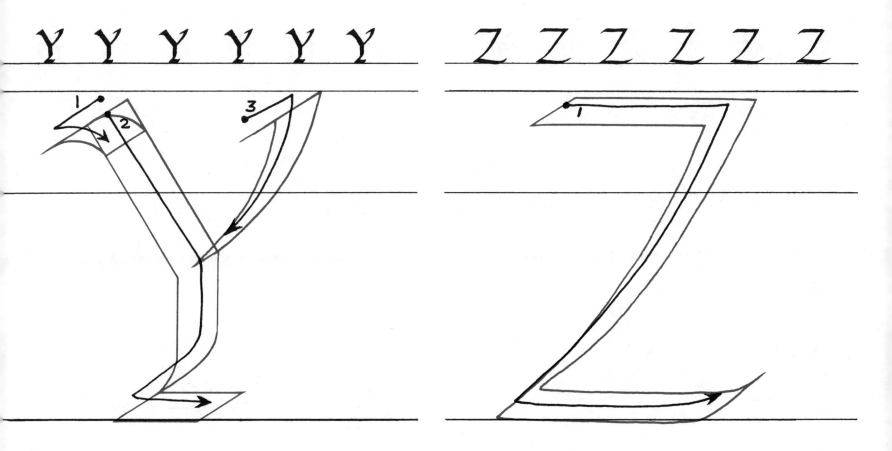

& & & & & &

12 12 12 12 12 12

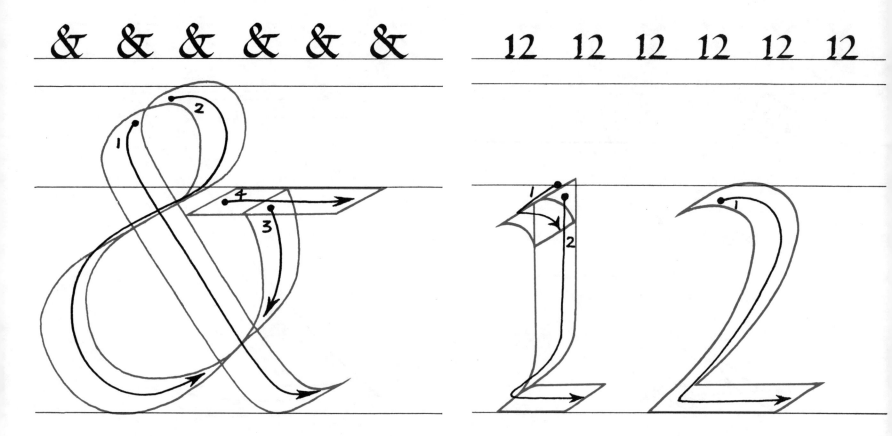

3 3 3 3 3 3 4 4 4 4 4 4

5 5 5 5 5 5 6 6 6 6 6 6

7 7 7 7 7 7

8 8 8 8 8 8

9 9 9 9 9 9 9 0 0 0 0 0 0

£ £ £ £ £ £

$ $ $ $ $ $

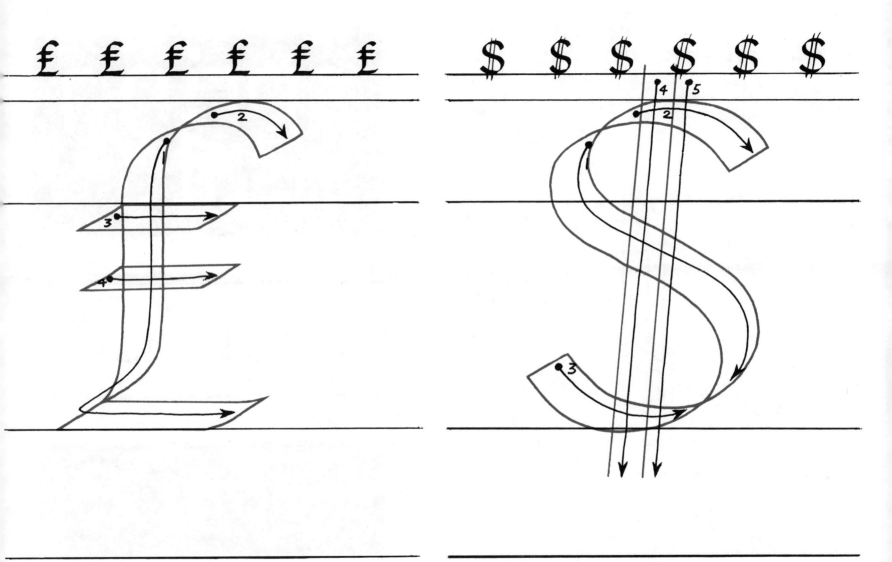

club meeting

"ECOLOGY"

speaker James Smith

discussion

coffee

22 May at 7 pm

Always leave a good margin at the bottom

Pater noster

qui es in coelis : sanctificetur nomen tuum. Adveniat regnum tuum. Fiat voluntas tua, sicut in coelo et in terra. Panem nostrum quotidianum da nobis hodie. Et dimitte nobis debita nostra, sicut et nos dimittimus debitoribus nostris. Et ne nos inducas in tentationem. Sed libera nos a malo. amen

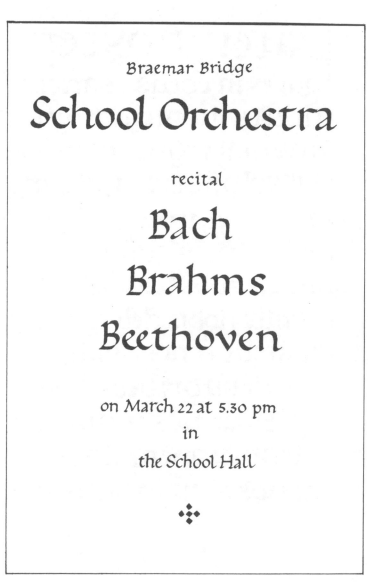

Braemar Bridge

School Orchestra

recital

Bach

Brahms

Beethoven

on March 22 at 5.30 pm

in

the School Hall

❖

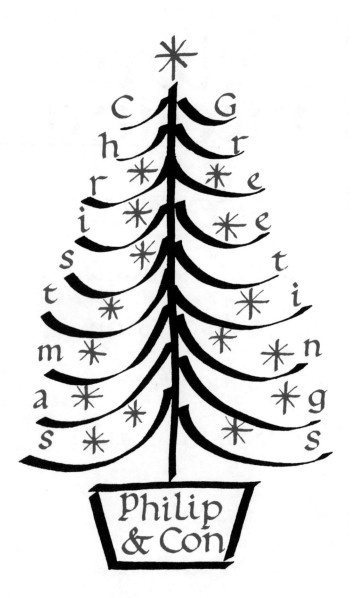

Christmas Greetings

Philip
& Con

black letter

Practise pen handling with the dummy
 pen point before you attempt the letters.
 Most letters can be written with only one
 or two of the strokes in the diagram.
These large sweeping movements help to fix
 the right movements and sequences in the
 mind, and re-educate the writing muscles.
Use a light touch to counter the "death grip"
 used by so many - the cause of writers' cramp.
It is most important to keep the writing edge
 of your pen in contact with the paper all along
 its width, AND at the same angle as the
 dotted lines, no matter whether you are
 making straight or curved lines. Beginners
 often turn the wrist and the pen edge to follow
 a curve. Resist the temptation to do this!

80

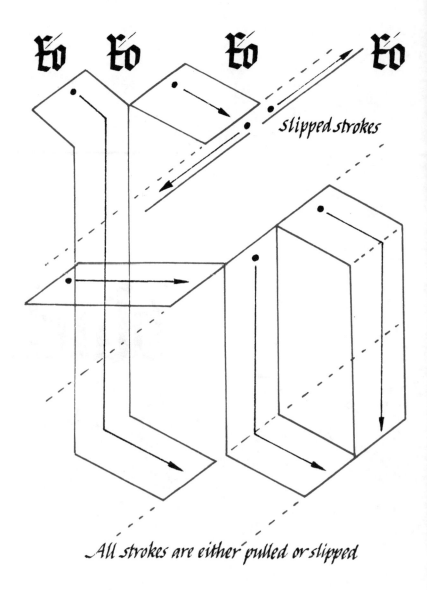

slipped strokes

All strokes are either pulled or slipped

𝖆 𝖆 𝖆 𝖆 𝖆 𝖆 𝖇 𝖇 𝖇 𝖇 𝖇 𝖇

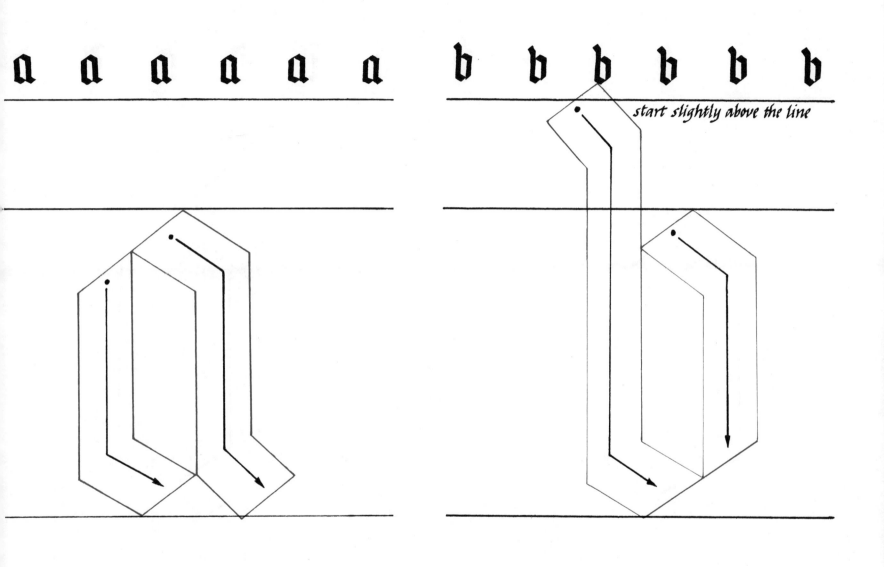

start slightly above the line

c c c c c c d d d d d d

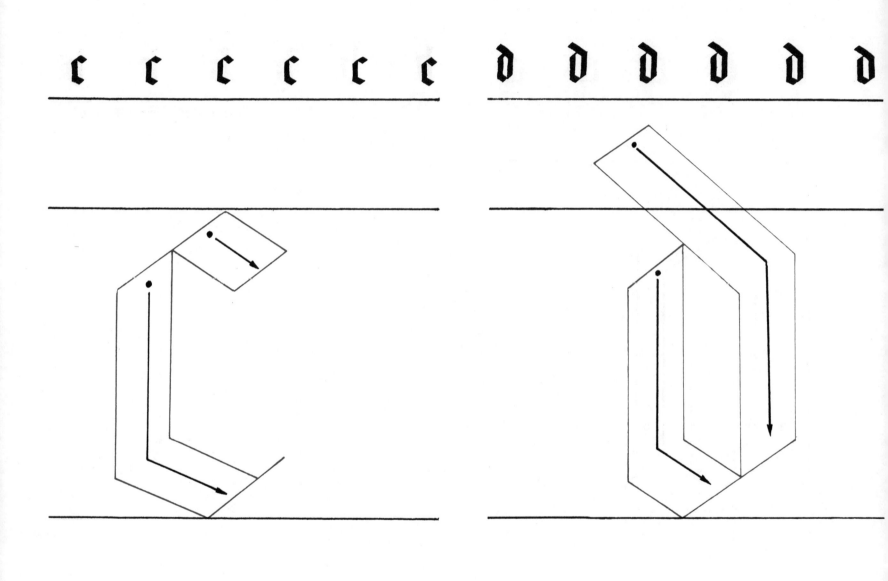

e e e e e e f f f f f f

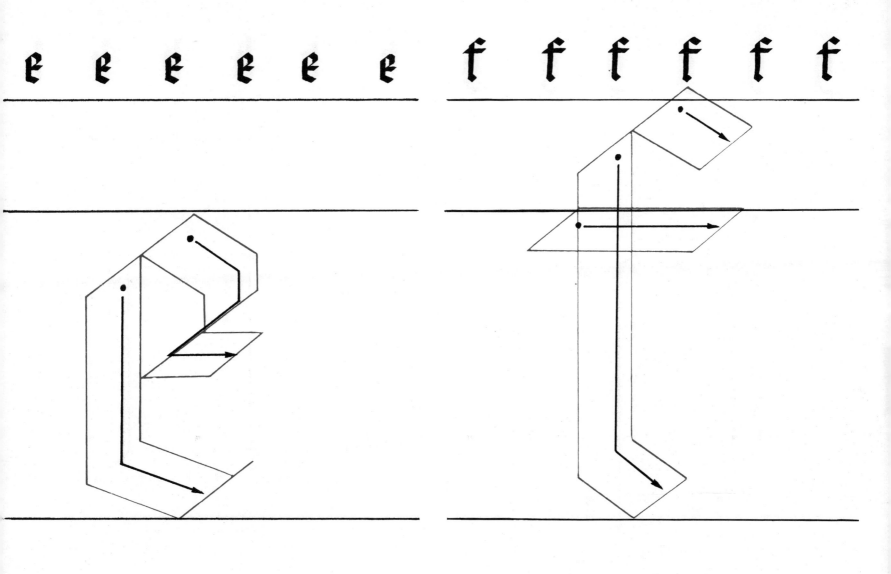

𝔤 𝔤 𝔤 𝔤 𝔤 𝔤 𝔥 𝔥 𝔥 𝔥 𝔥 𝔥

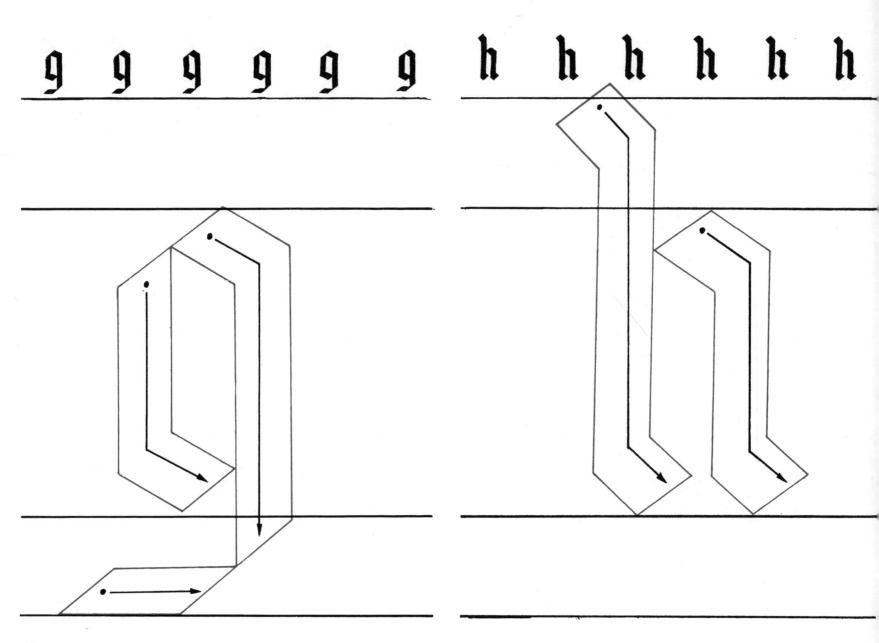

ÿ ÿ ÿ ÿ ÿ ÿ k k k k k k

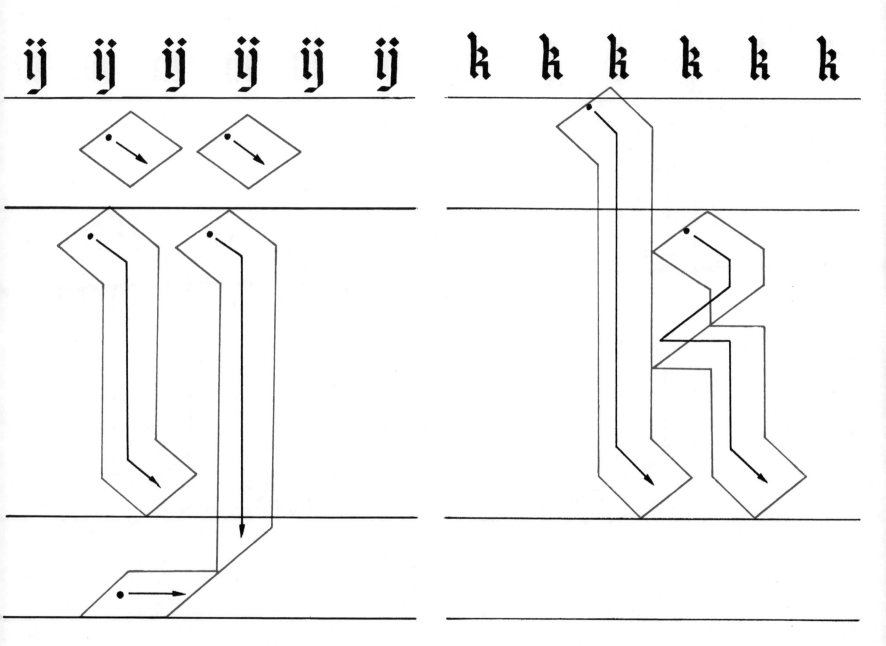

𝔩 𝔩 𝔩 𝔩 𝔩 𝔩 𝔪 𝔪 𝔪 𝔪 𝔪 𝔪

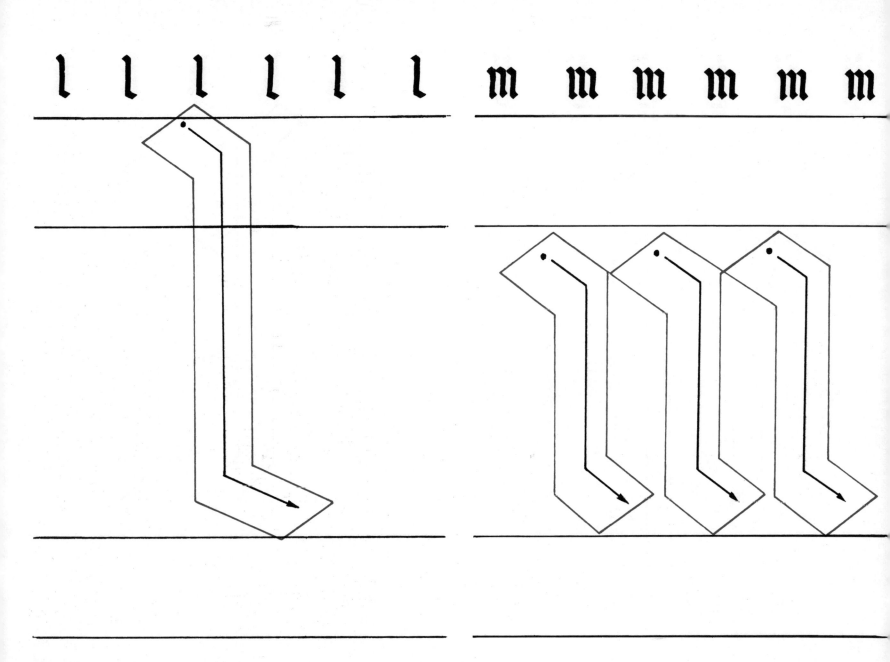

n n n n n n o o o o o o

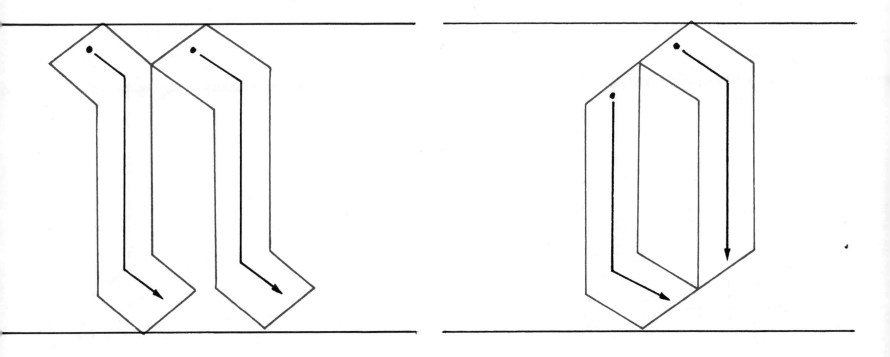

𝔭 𝔭 𝔭 𝔭 𝔭 𝔭 𝔮 𝔮 𝔮 𝔮 𝔮 𝔮

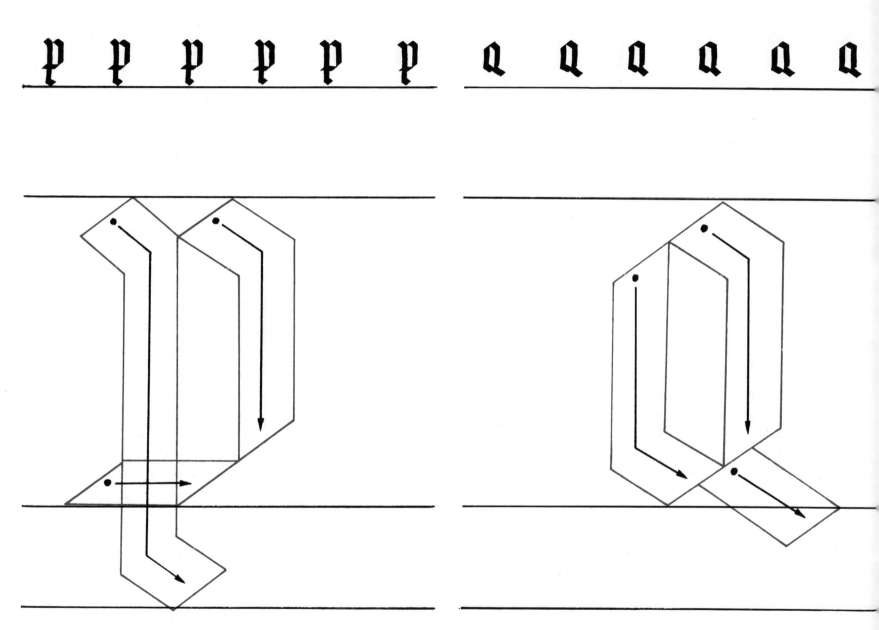

r r r r r r r s s s s s s

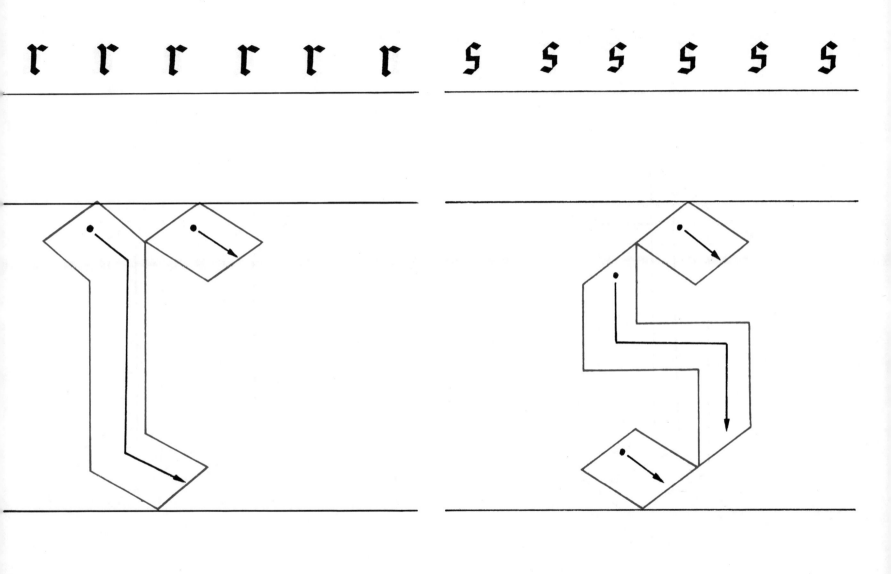

t t t t t t u u u u u u

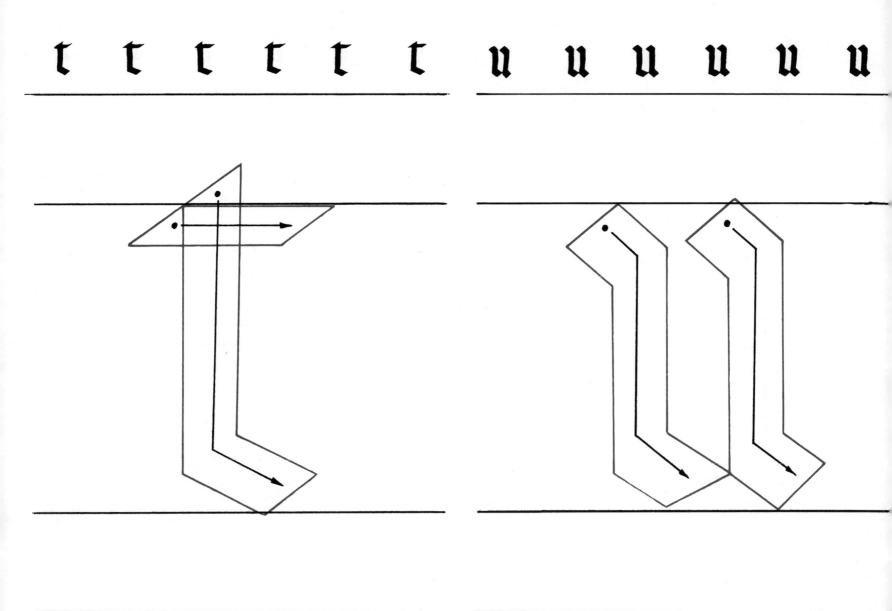

v v v v v v w w w w w w

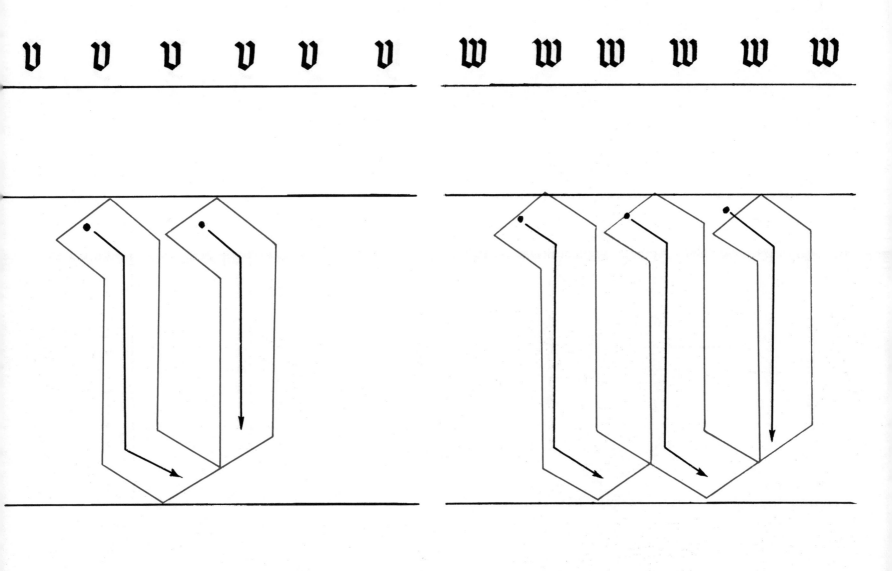

𝔵 𝔵 𝔵 𝔵 𝔵 𝔵 𝔶 𝔶 𝔶 𝔶 𝔶 𝔶

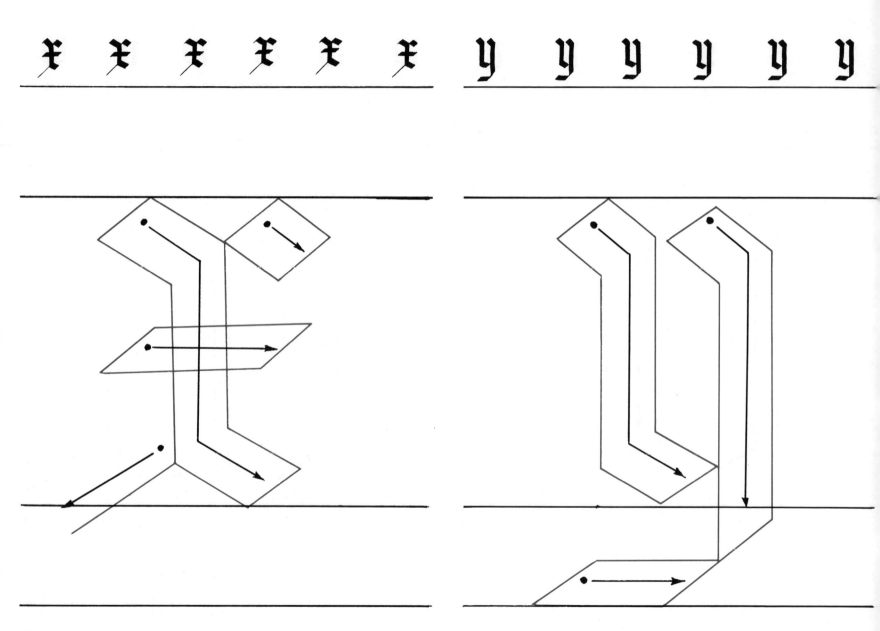

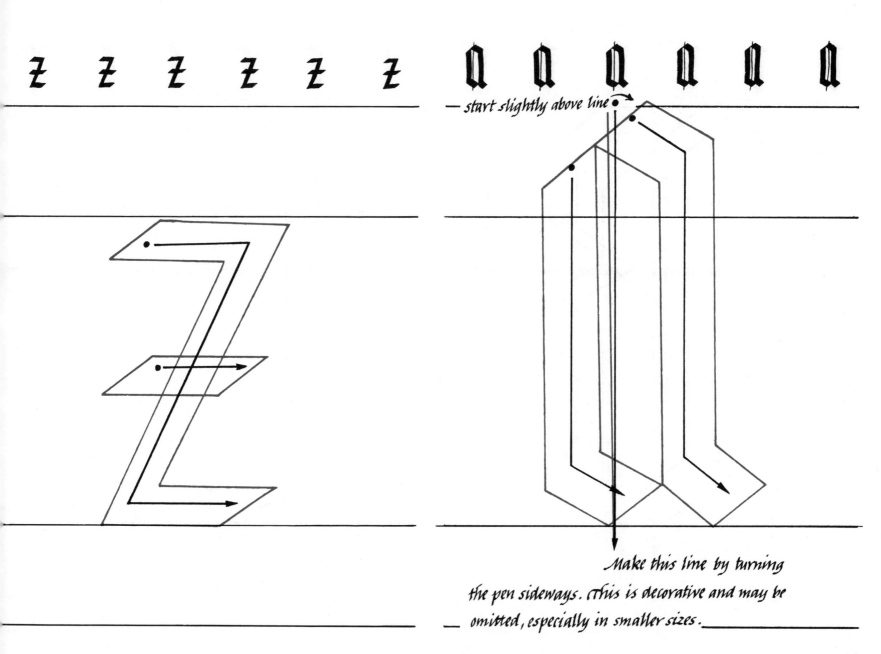

𝖟 𝖟 𝖟 𝖟 𝖟 𝖟 𝖆 𝖆 𝖆 𝖆 𝖆 𝖆

— *start slightly above line*

Make this line by turning
the pen sideways. This is decorative and may be
omitted, especially in smaller sizes.

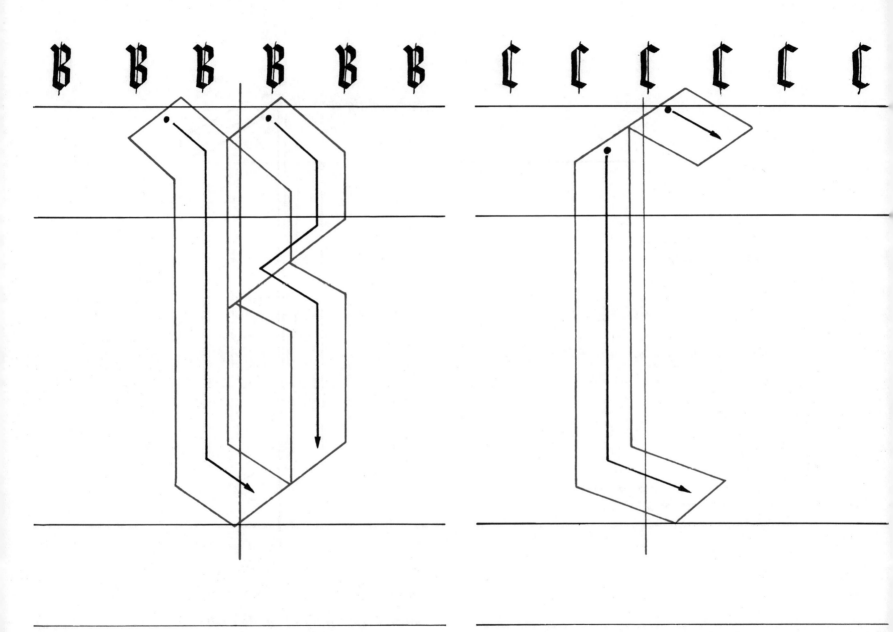

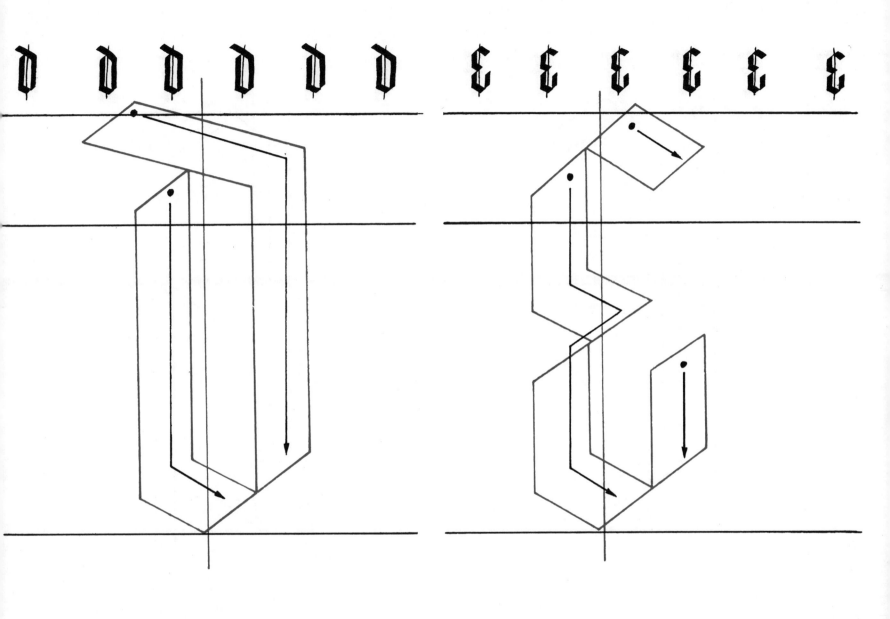

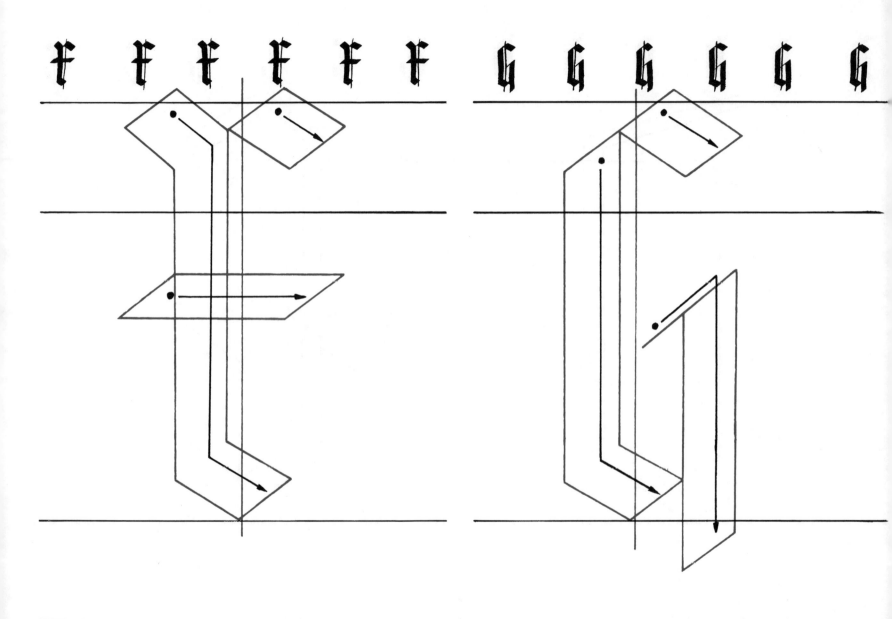

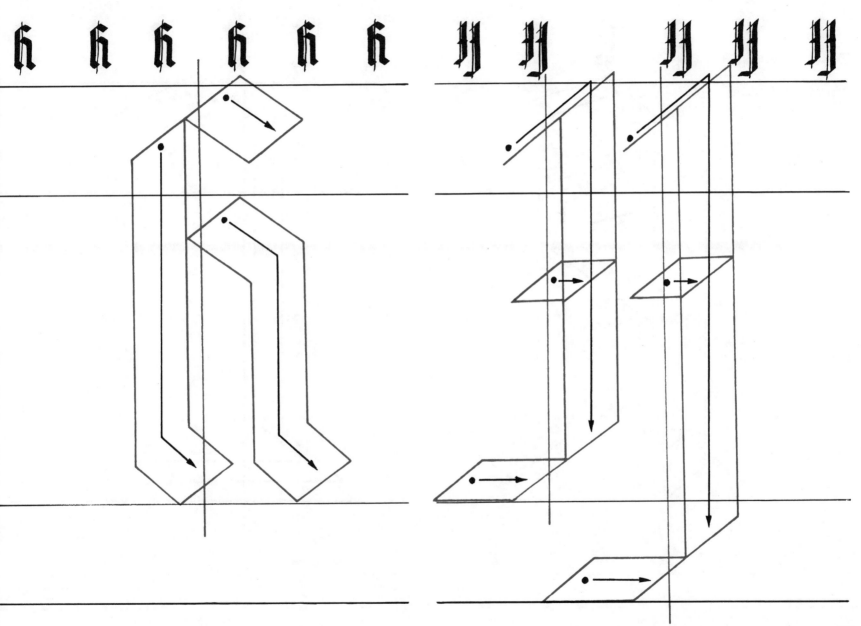

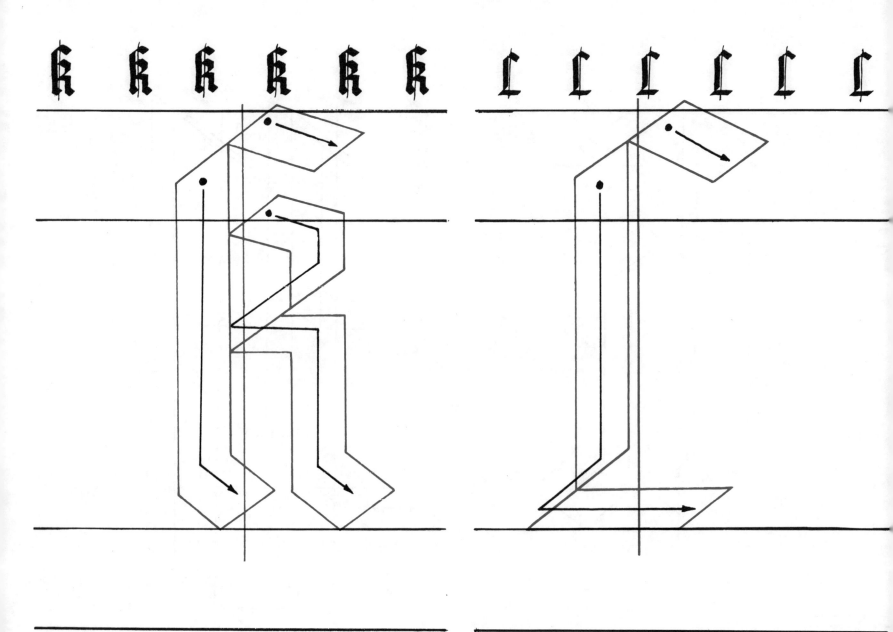

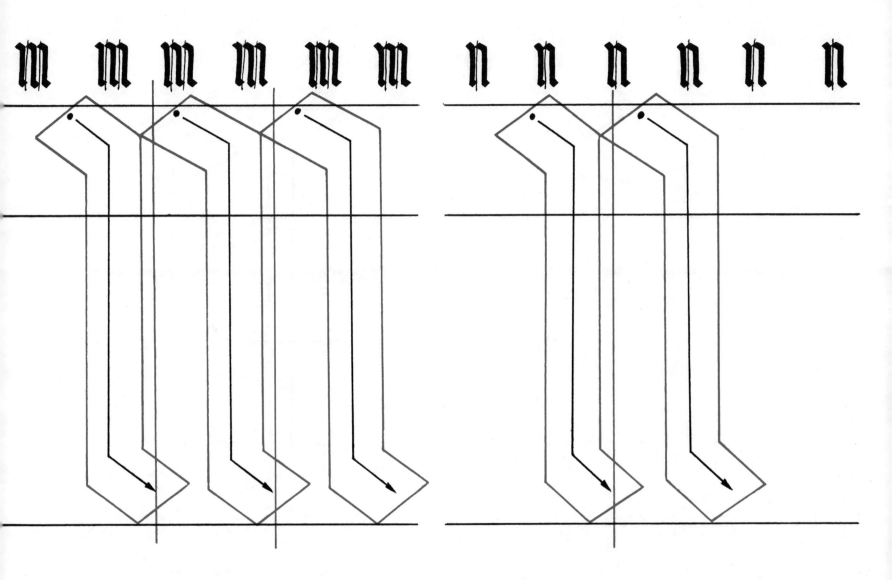

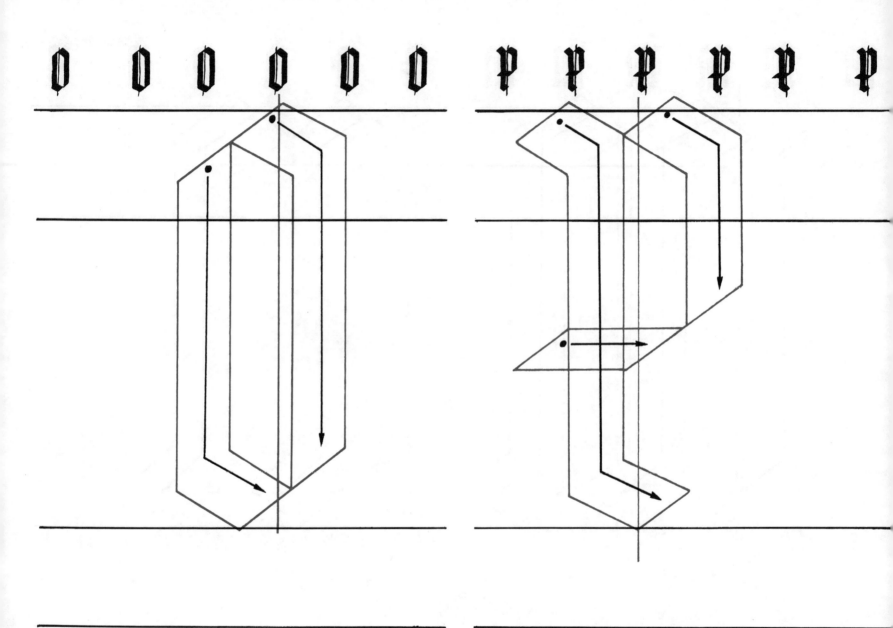

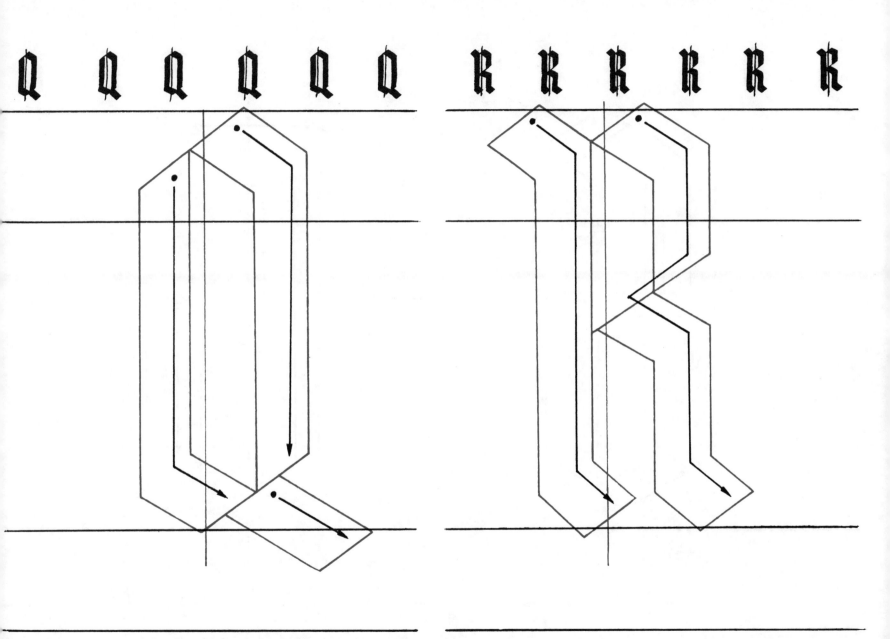

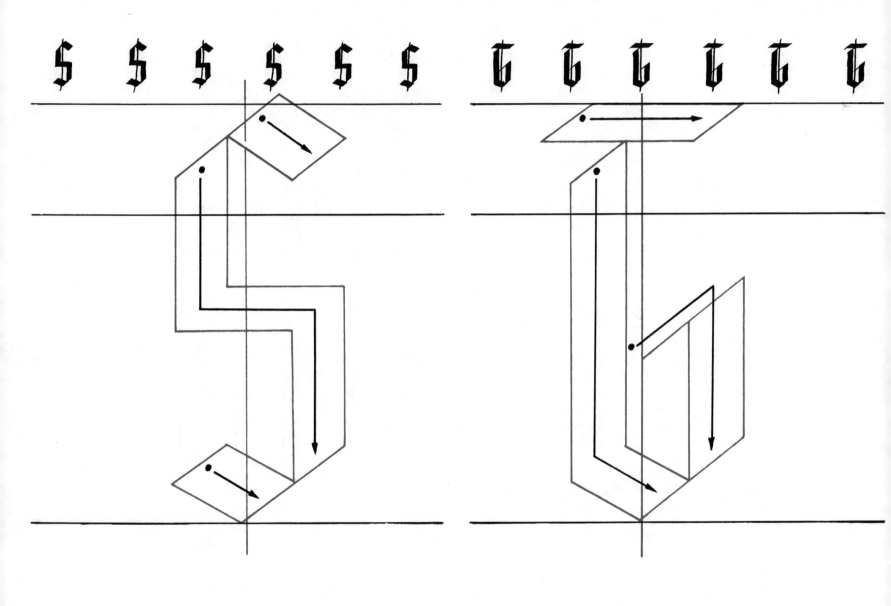

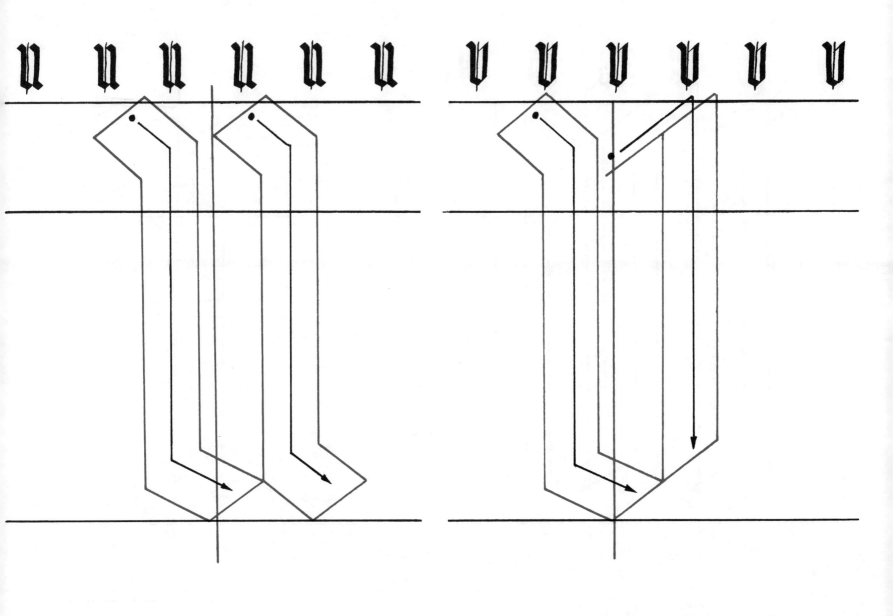

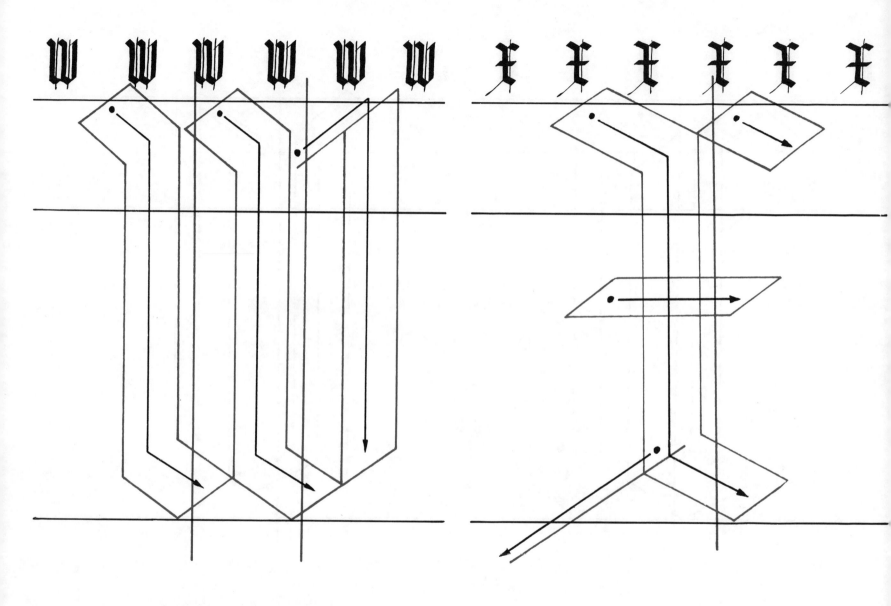

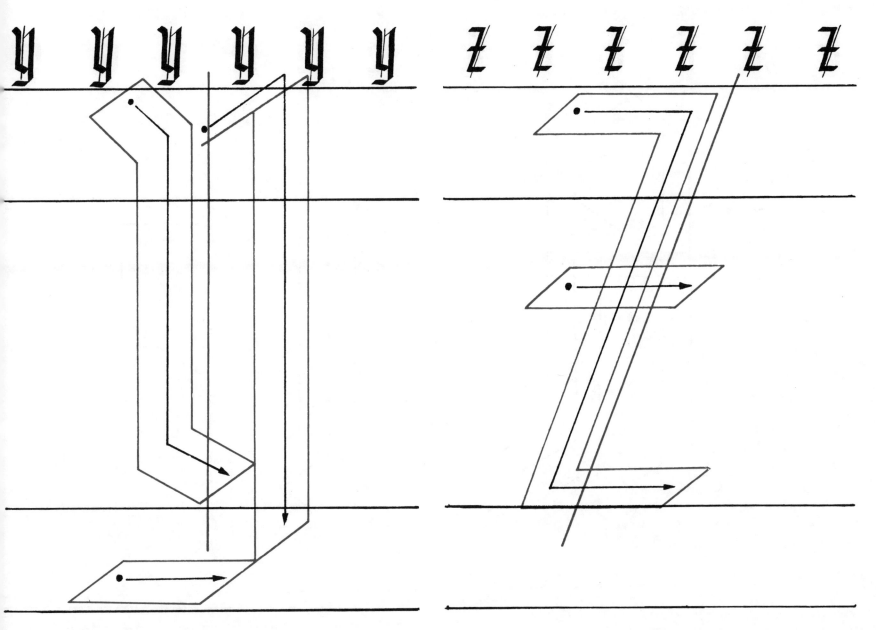

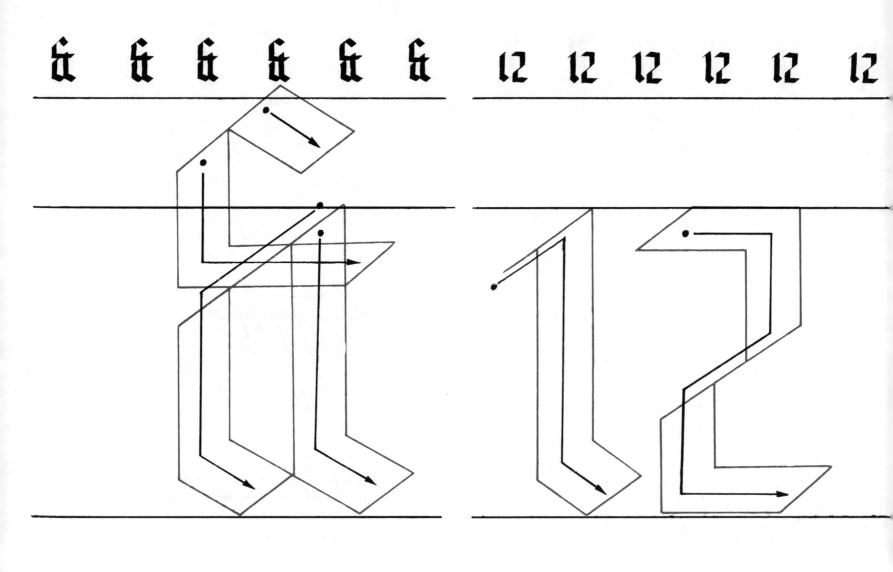

106

3 3 3 3 3 3 4 4 4 4 4 4

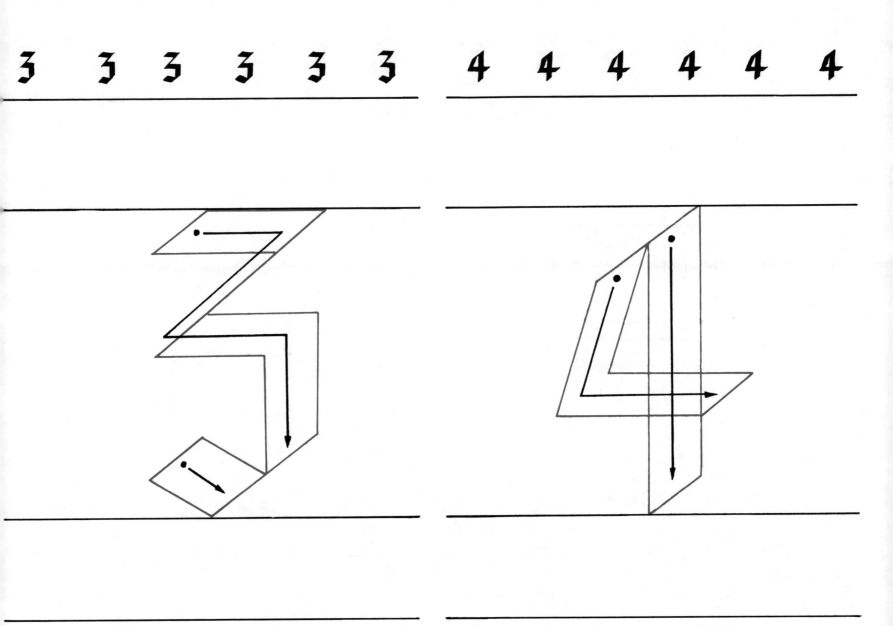

𝔖 𝔖 𝔖 𝔖 𝔖 𝔖 𝔖 𝔖 𝔖 𝔖 𝔖 𝔖

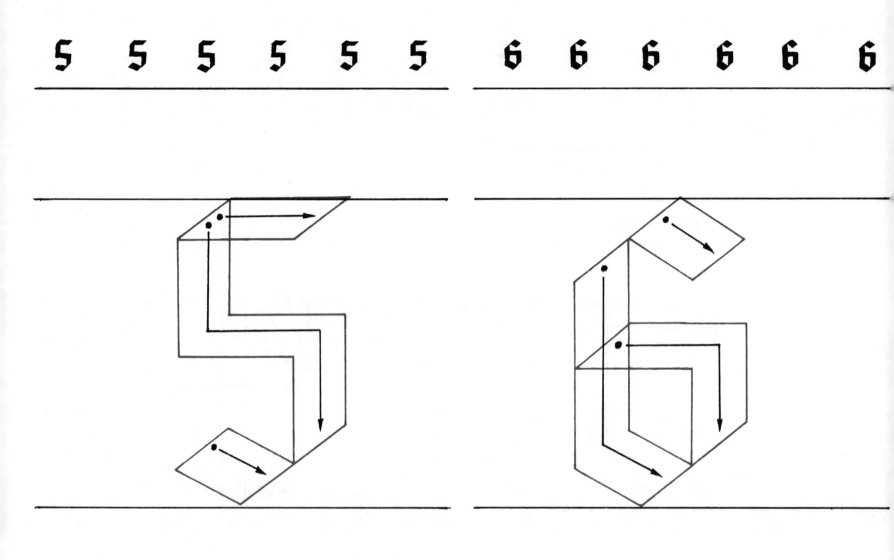

7 7 7 7 7 7 8 8 8 8 8 8

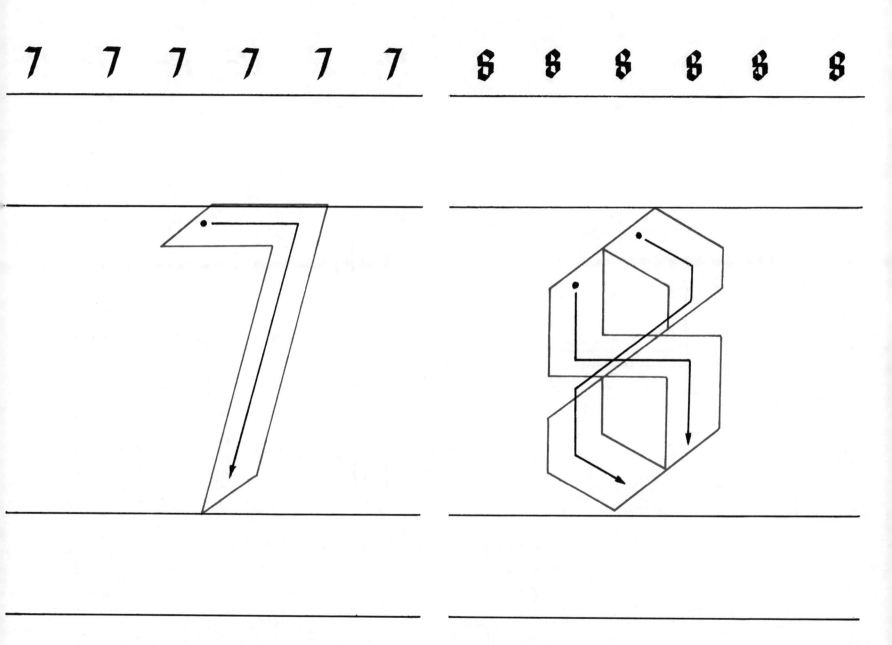

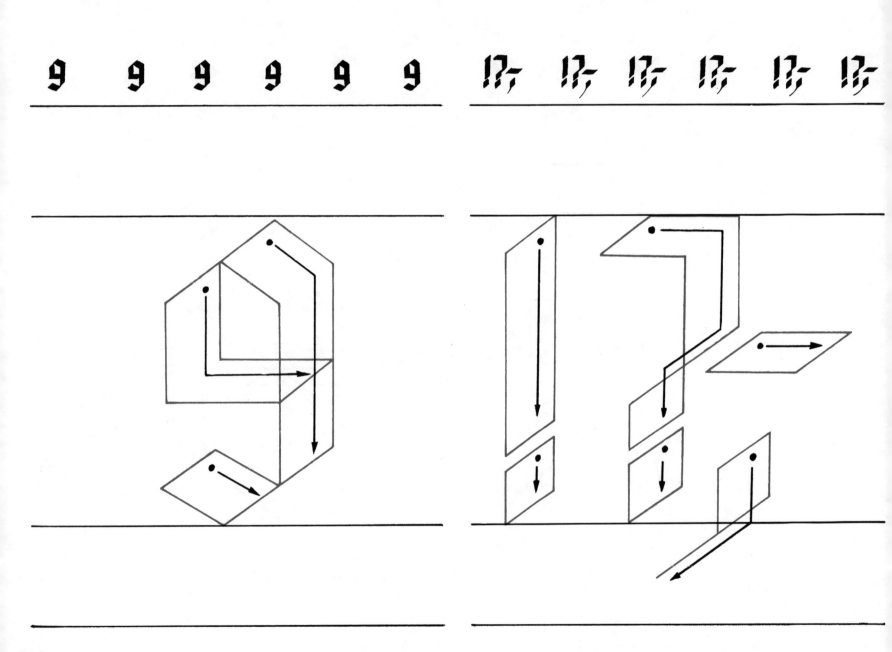

£$ £$ £$ £$ £$ £$

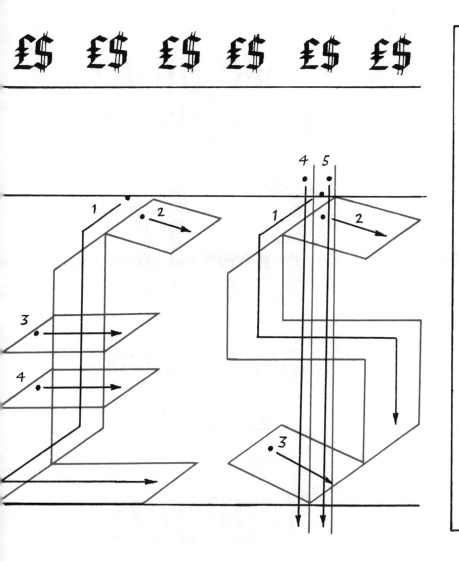

Certificate
of merit
presented to
John M Smith
on completing a prime
course of studies at the
Green Valley College

Verdi

Beethoven

Schubert

Boccherini

Tchaikowsky

Bed and
Breakfast

Exit

contributions

Sale

Souvenirs

Contrary to expectations, this is perhaps the easiest to write, as all the lines are straight.

abcdefghijk lmnopqrstu vwxyz

To add hair lines, slide your pen sideways.

abcdefghijkl

Experiment with different heights, using same pen

mnopqrstuvw xyz

Better
is a dinner of
herbs
where love is
than a fatted ox
and hatred
with it

Bar

Certificate

Entrance

no . admittance

Vacancies

Out

Corot

Rembrandt

Constable

Botticelli

Mantegna

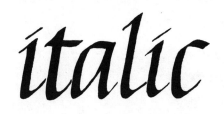

italic

Practise pen handling with the dummy
pen point before you attempt the letters.
Most letters can be written with only one
or two of the strokes in the diagram.
These large sweeping movements help to fix
the right movements and sequences in the
mind, and re-educate the writing muscles.
Use a light touch to counter the "death grip"
used by so many - the cause of writers' cramp.
It is most important to keep the writing edge
of your pen in contact with the paper all along
its width, AND at the same angle as the
dotted lines, no matter whether you are
making straight or curved lines. Beginners
often turn the wrist and the pen edge to follow
a curve. Resist the temptation to do this!

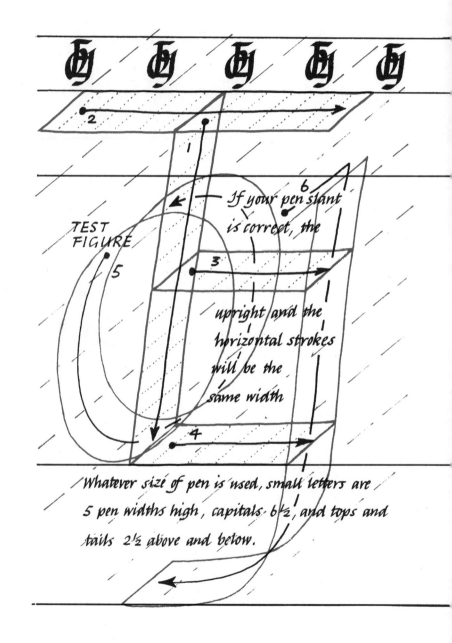

TEST
FIGURE

If your pen slant
is correct, the

upright and the
horizontal strokes
will be the
same width

Whatever size of pen is used, small letters are
5 pen widths high, capitals 6½, and tops and
tails 2½ above and below.

116

a a a a a a a a a a *b b b b b b b b b*

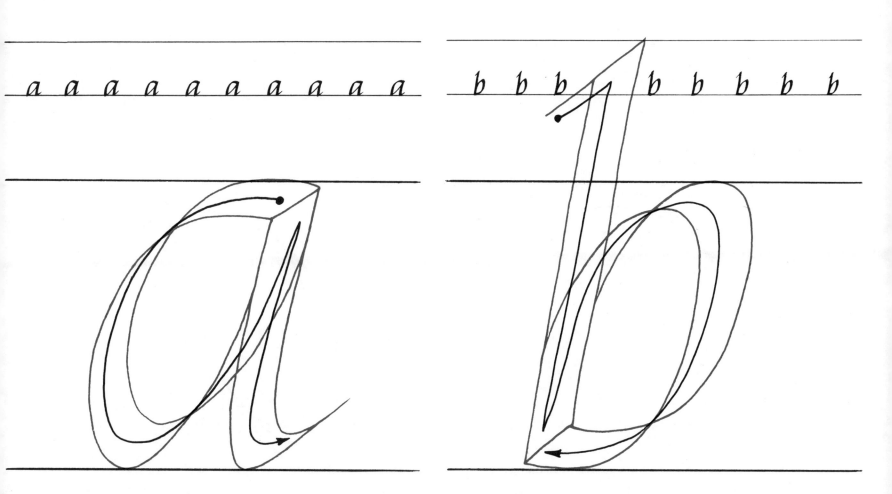

When practising on these large letters, use
the whole arm, and do not move the wrist.

c c c c c c c c c d d d d d d d d d

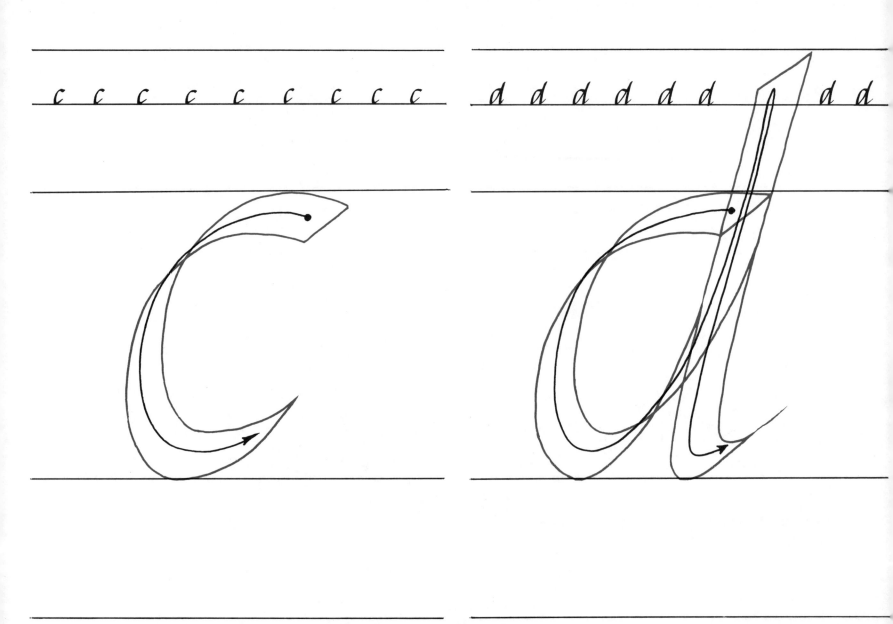

e e e e e e e e e f f f f f f f f

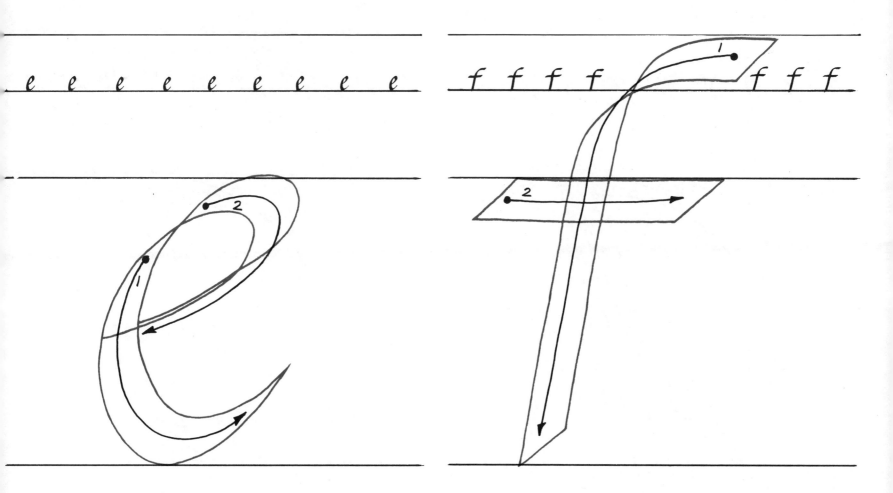

g g g g g g g g g h h h h h h h h h

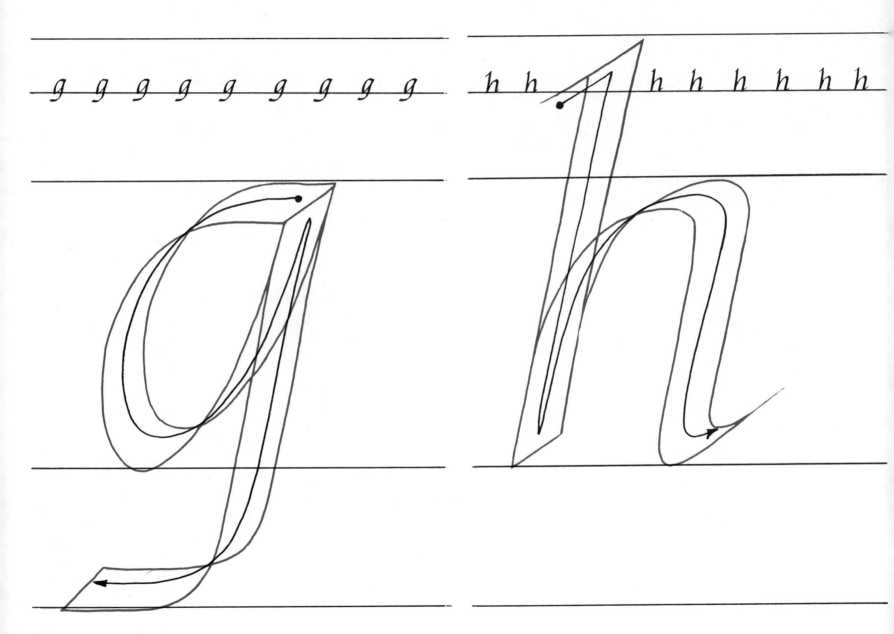

ij *ij* *ij* *ij* *ij* *ij* *ij* *ij* *ij* *ij* *k* *k* *k* *k* *k* *k* *k* *k*

l *l* *l* *l* *l* *l* *l* *l* *l* *m* *m* *m* *m* *m* *m* *m* *m*

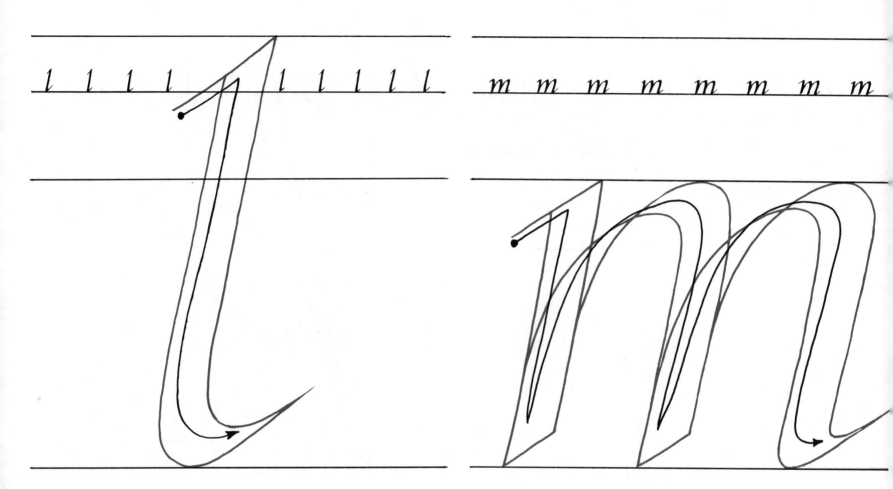

n *n* *n* *n* *n* *n* *n* *n* *o* *o* *o* *o* *o* *o* *o* *o*

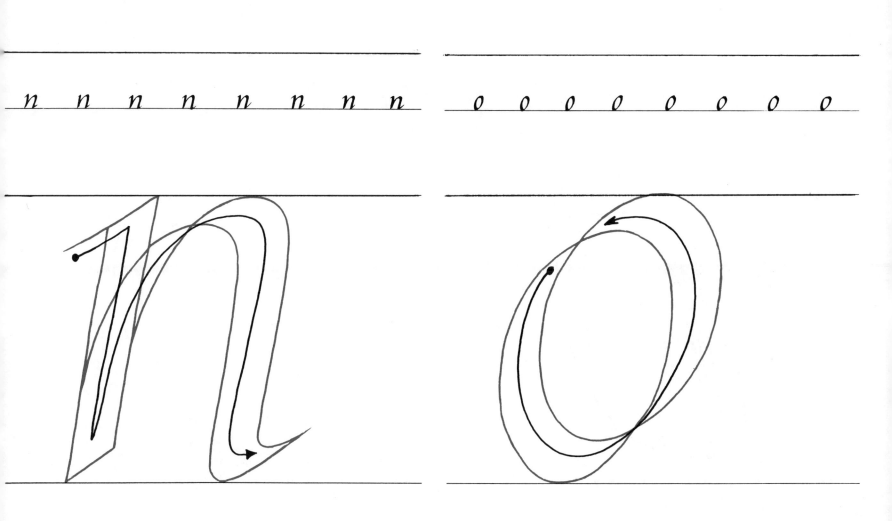

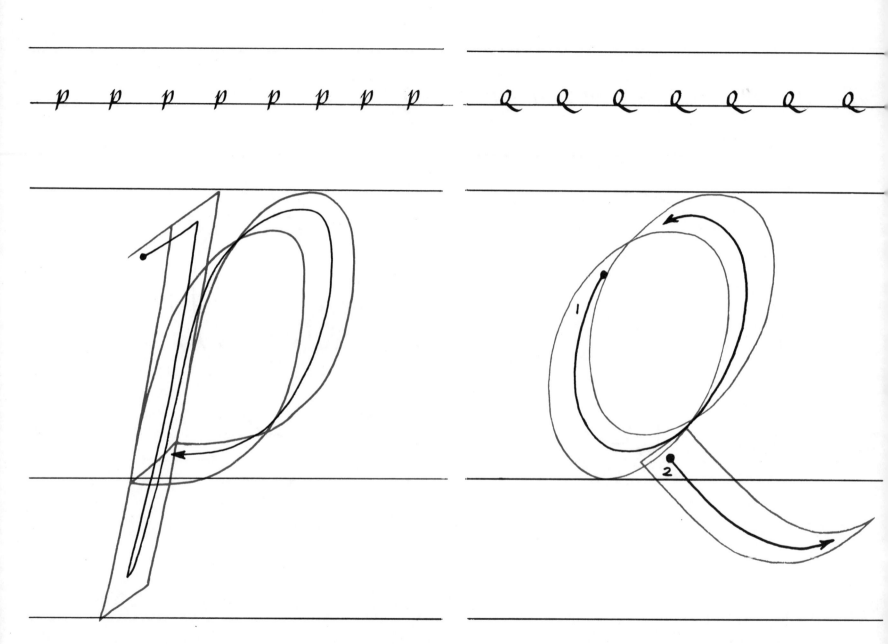

r r r r r r r r s s s s s s s

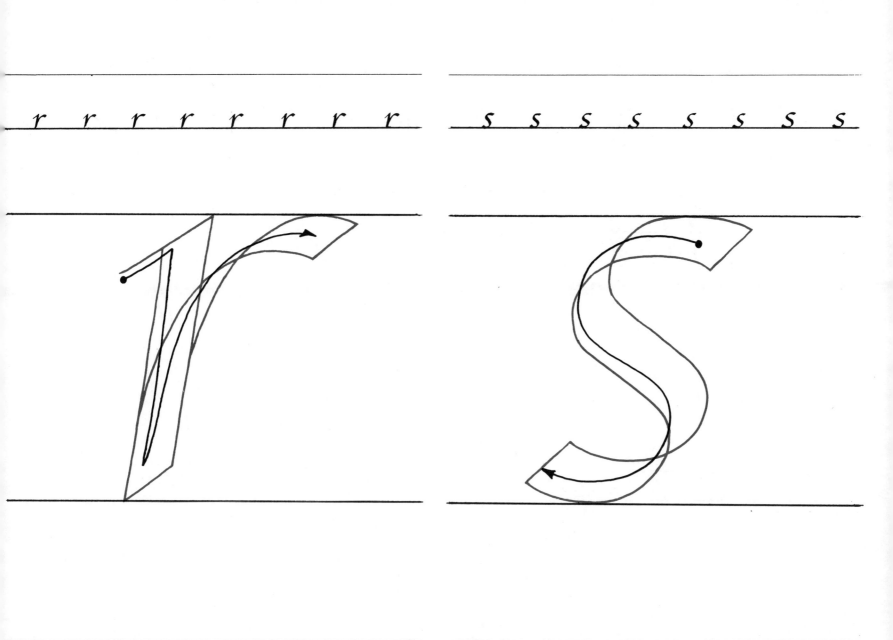

t t t t t t t t u u u u u u u u

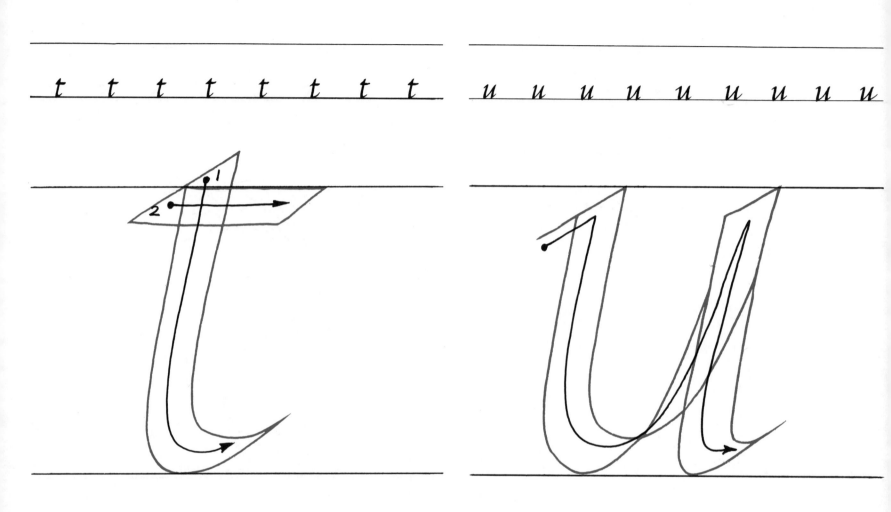

v *v* *v* *v* *v* *v* *v* *v* *v* *w* *w* *w* *w* *w* *w* *w* *w*

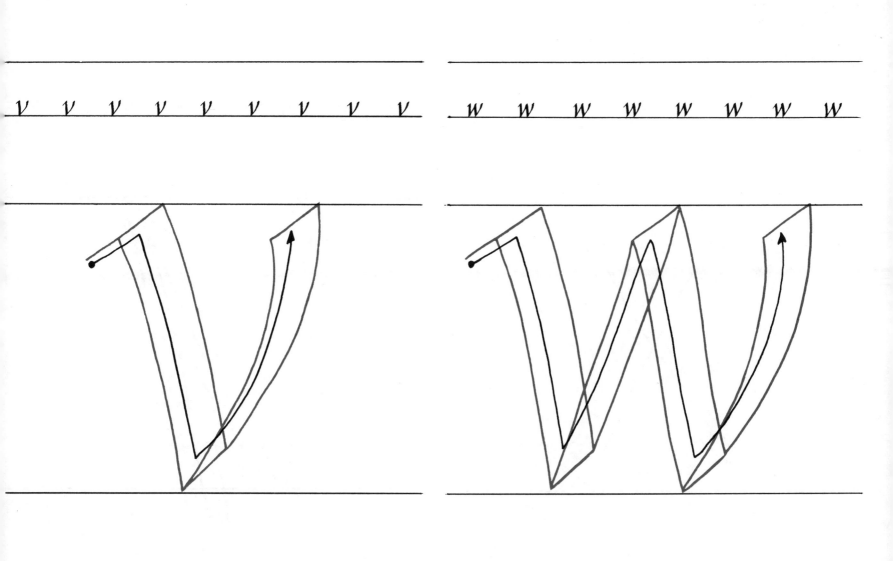

x x x x x x x x *y y y y y y y y y*

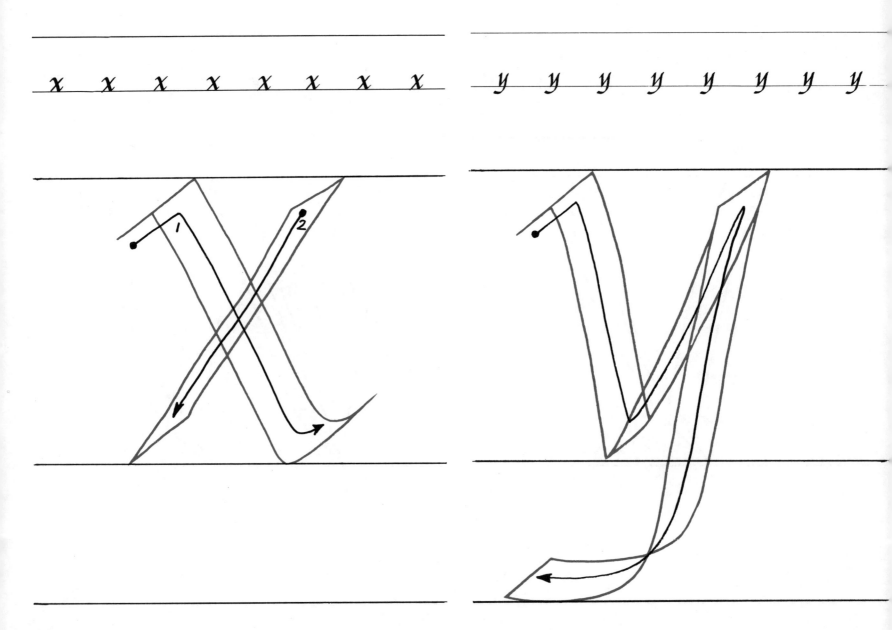

z z z z z z z z A A A A A A

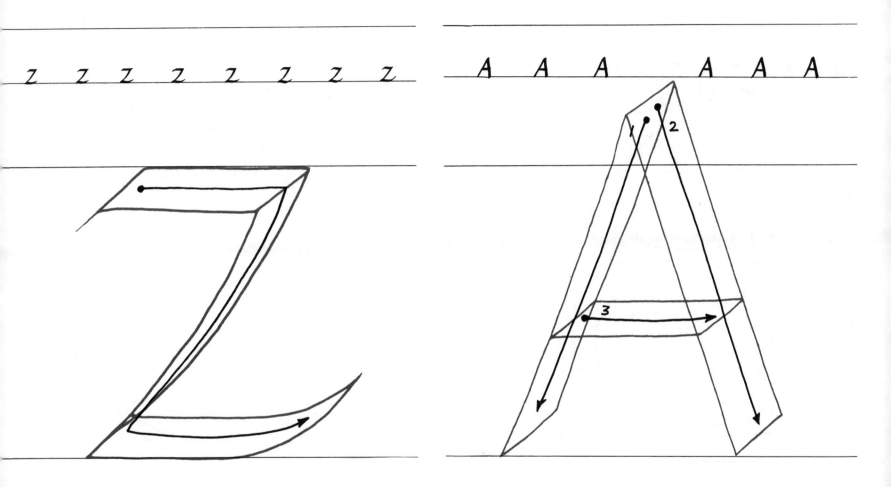

B *B* *B* *B* *B* *B* *B* *B* *C* *C* *C* *C* *C* *C* *C* *C*

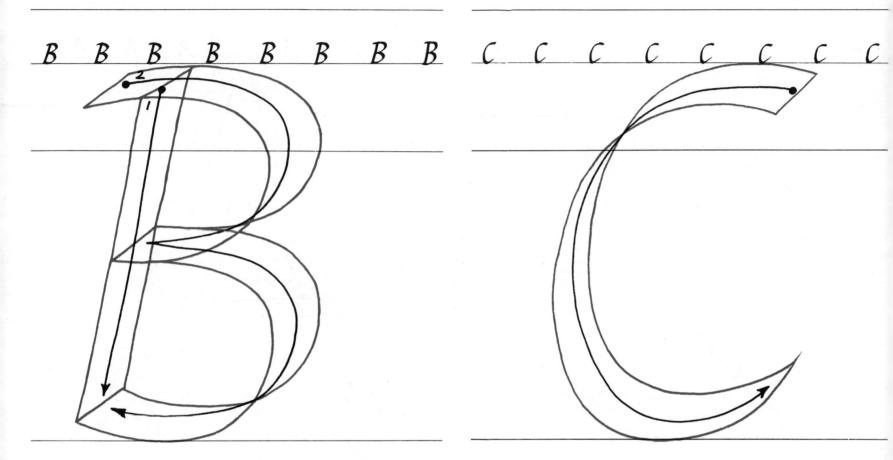

D D D D D D D D

E E E E E E

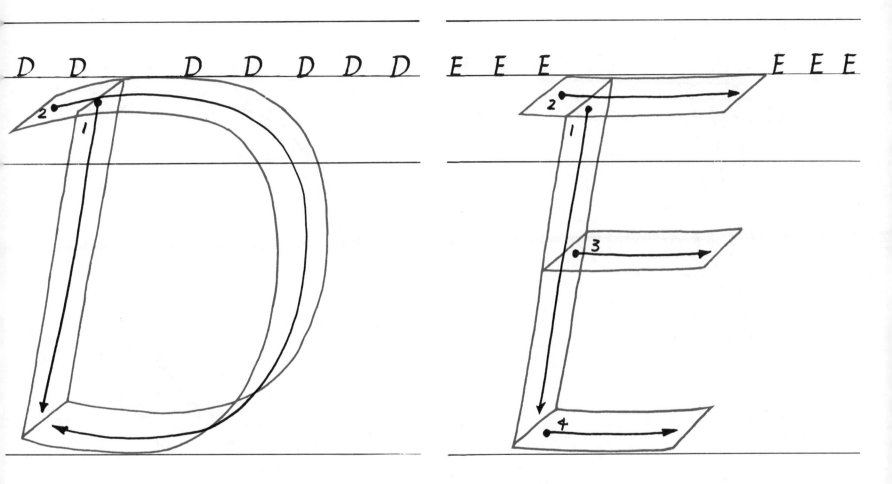

F F F F F F G G G G G G

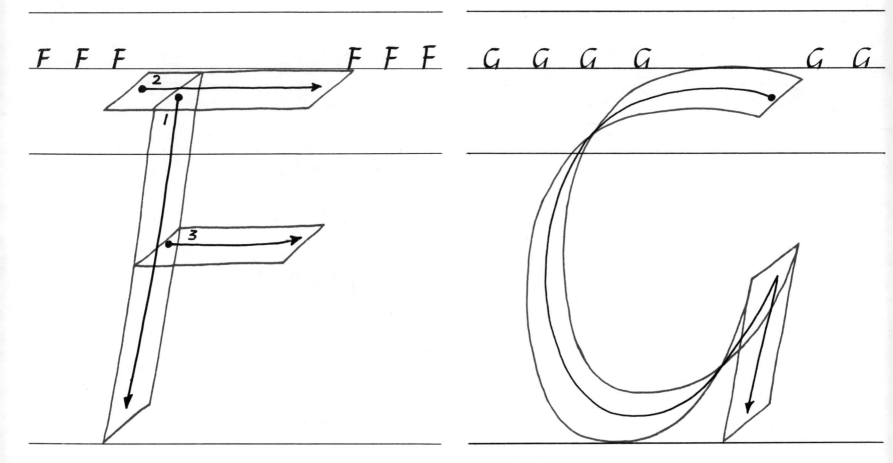

H H H H H H H

jj jj jj jj jj jj jj

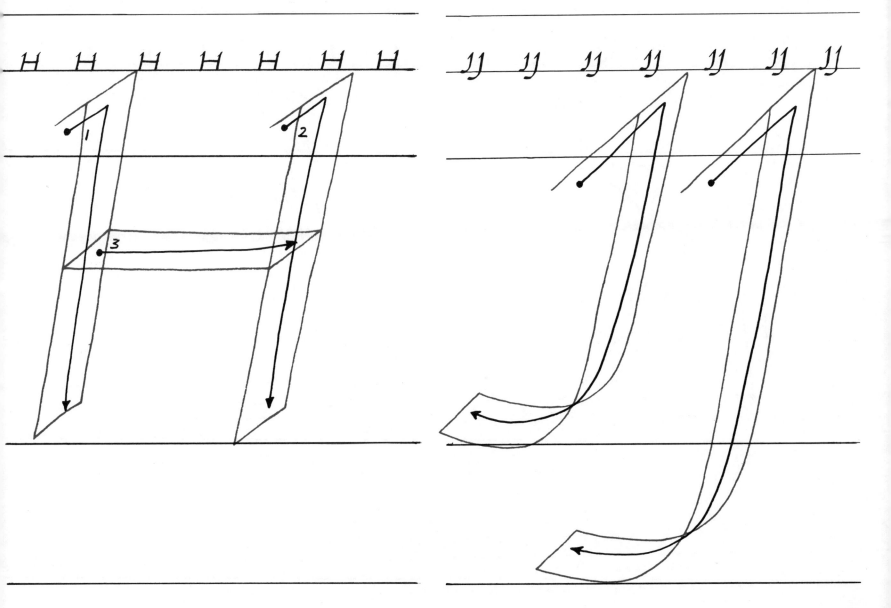

K K K K K K K L L L L L L L

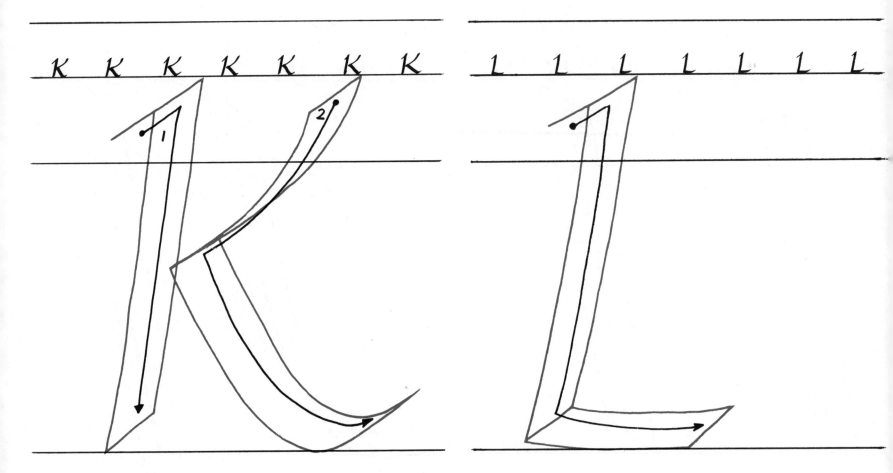

M M M M M M M N N N N N N

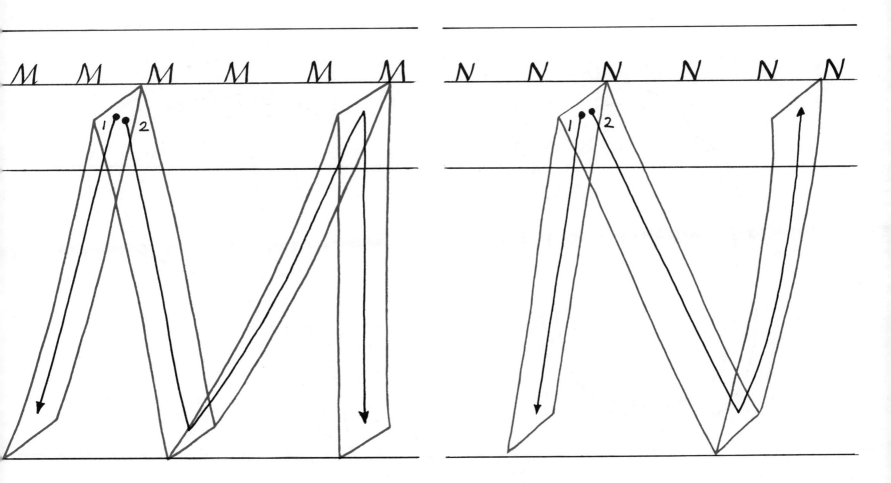

O O O O O O O P P P P P P P

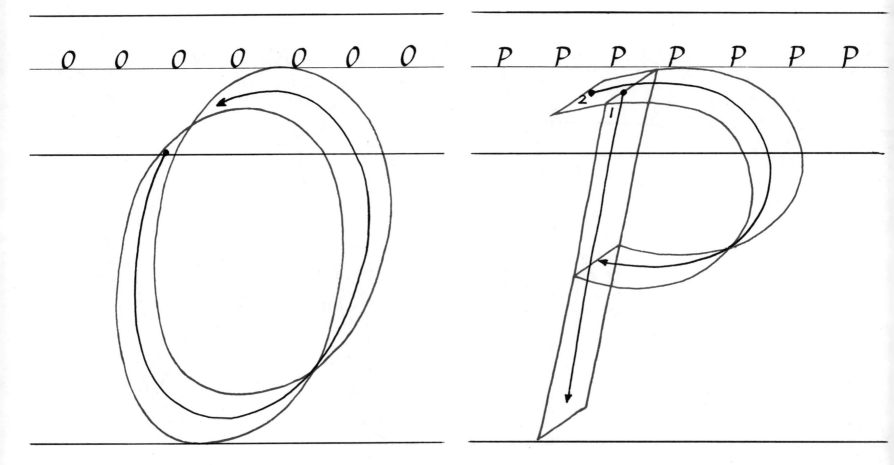

Q Q Q Q Q Q Q Q R R R R R R R

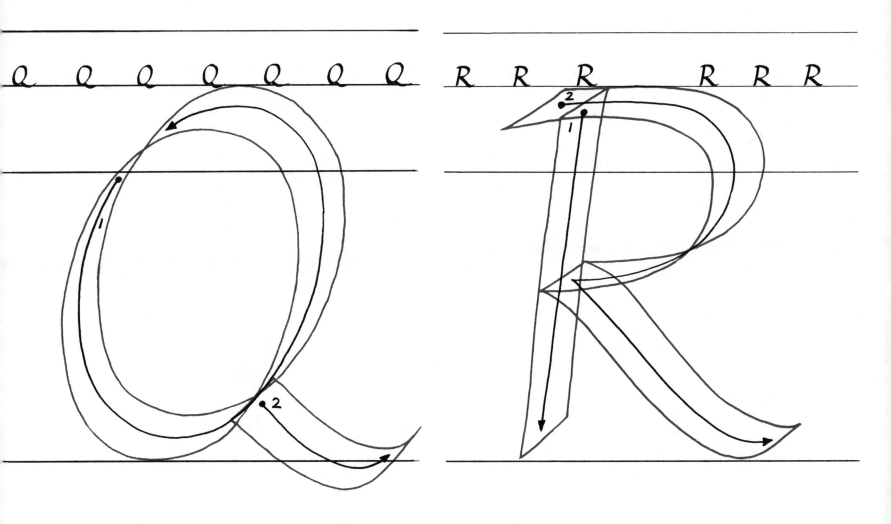

S S S S S S S S

T T T T T T T T

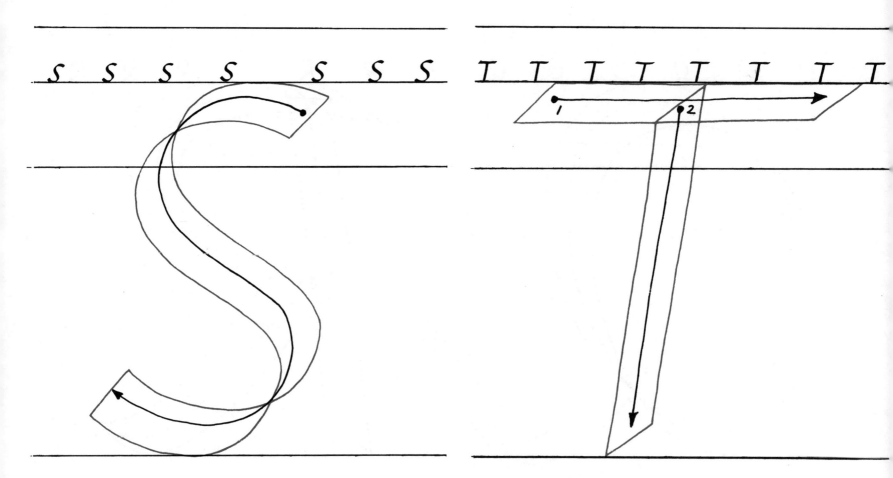

u u u u u u u

v v v v v v v

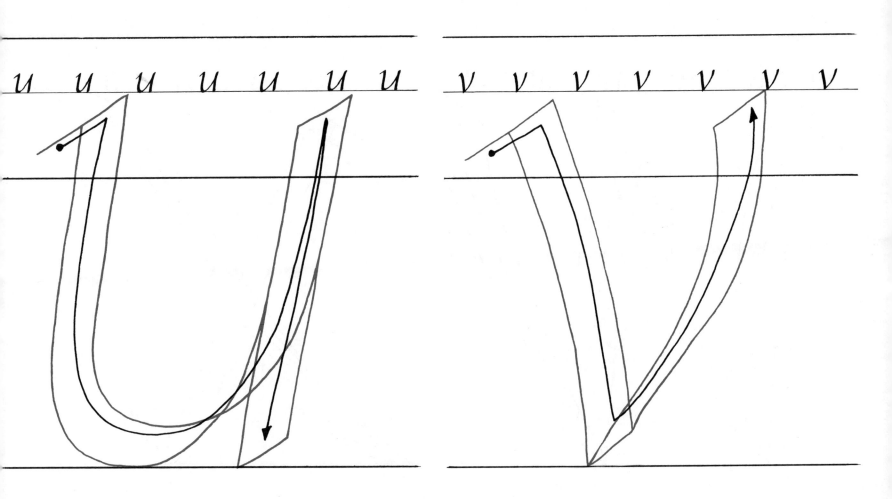

W W W W W W X X X X X X

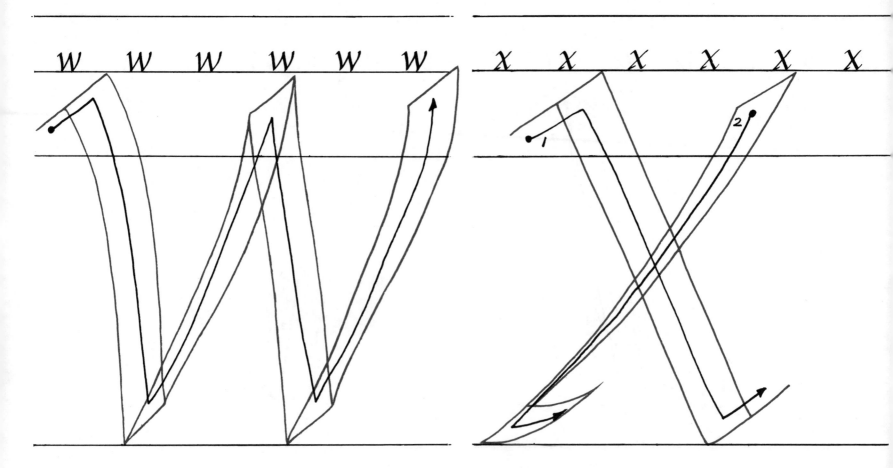

y y y y y y y

z z z z z z z

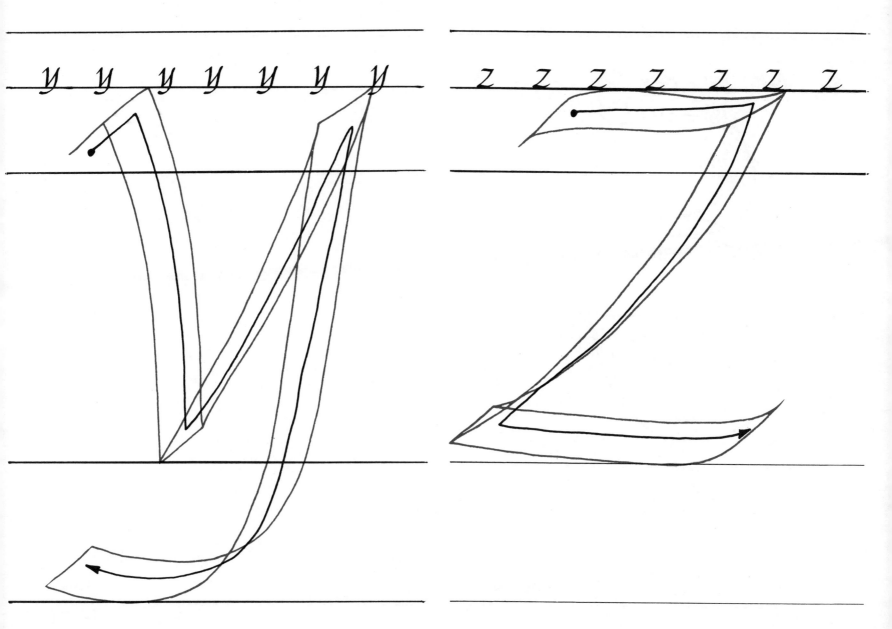

ℰ ℰ ℰ ℰ ℰ ℰ ℰ ℰ 1 1 1 1 1 1 1 1

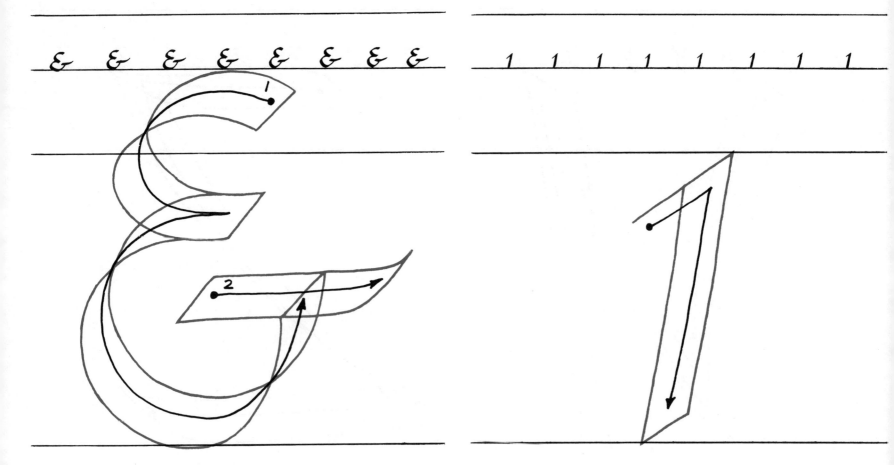

2 2 2 2 2 2 2 2 2

3 3 3 3 3 3 3 3 3

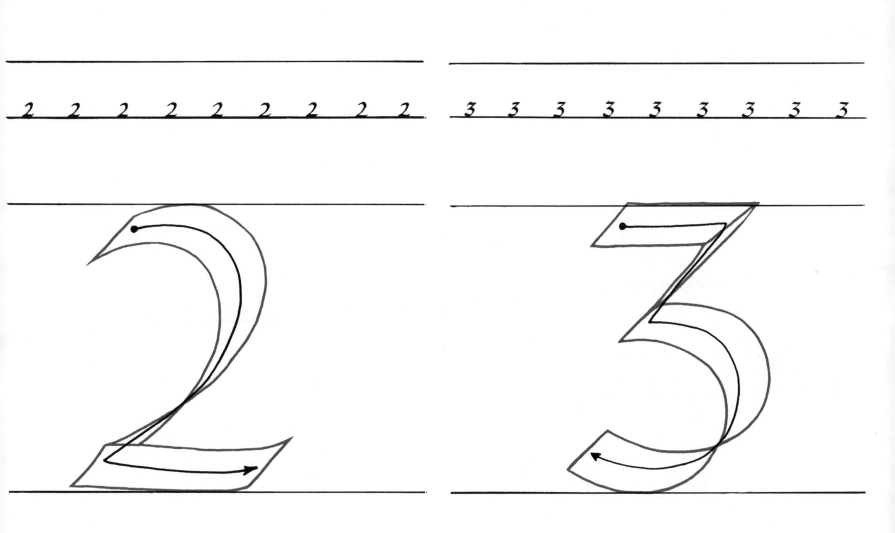

4 4 4 4 4 4 4 4

5 5 5 5 5 5 5 5

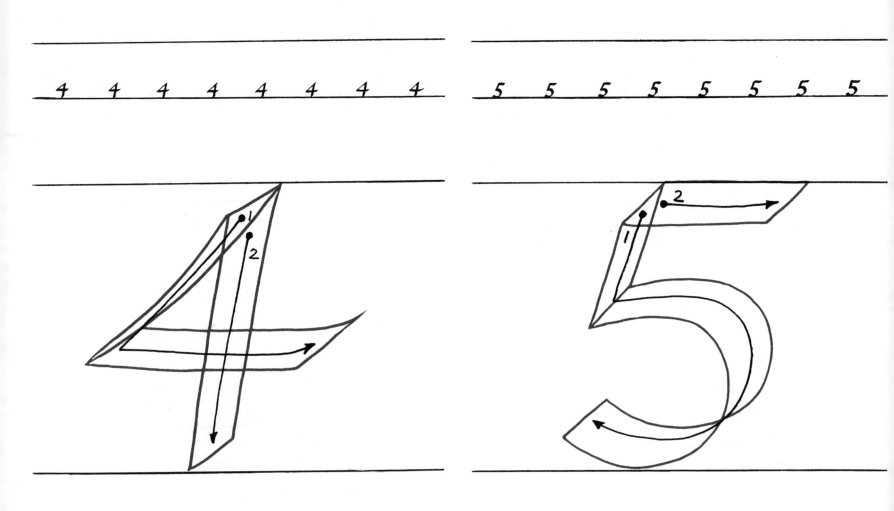

6 6 6 6 6 6 6 6

7 7 7 7 7 7 7 7

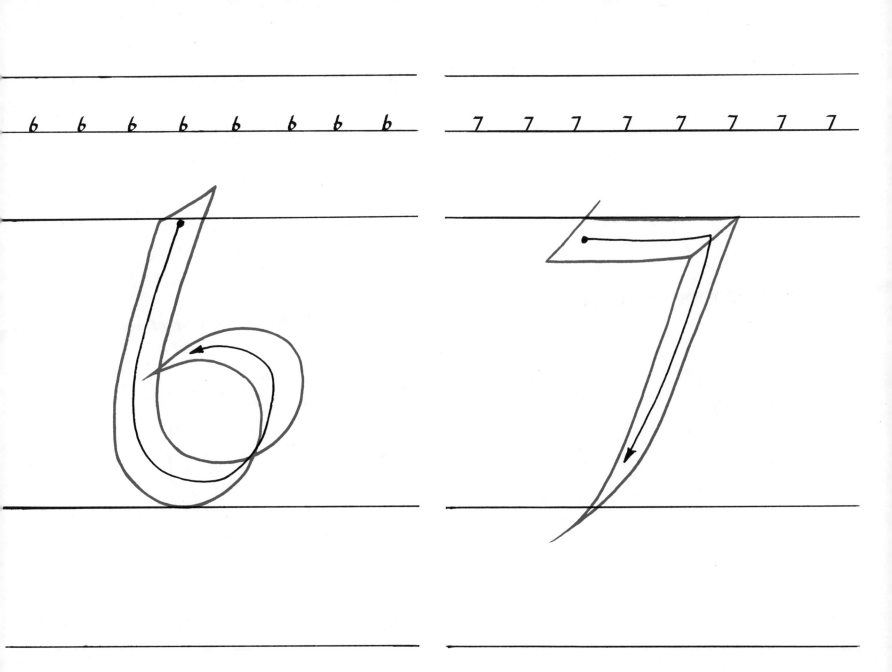

8 8 8 8 8 8 8 8

9 9 9 9 9 9 9 9

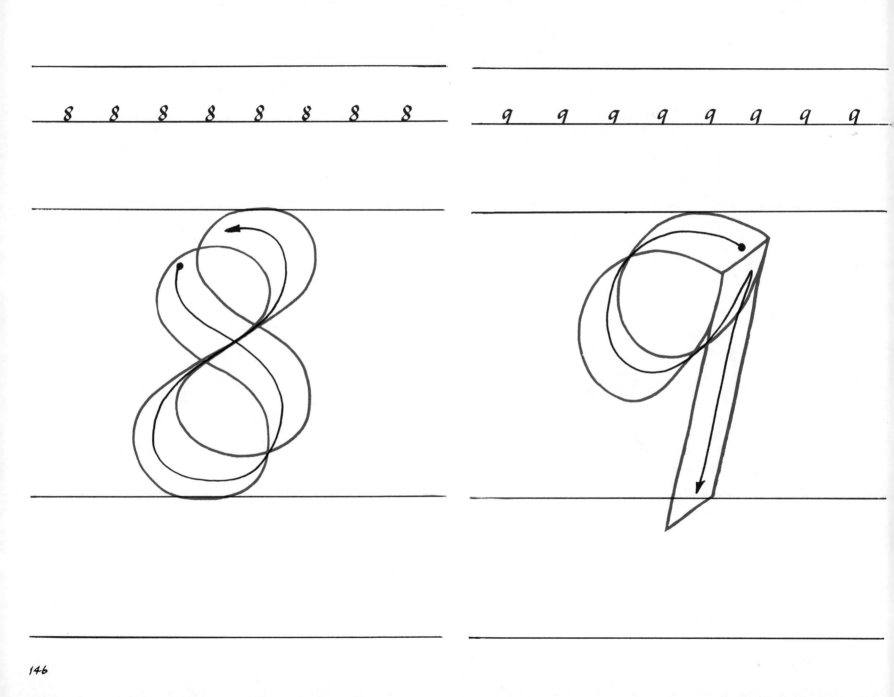

o o o o o o o o

£ £ £ £ £ £ £ £

$ $ $ $ $ $

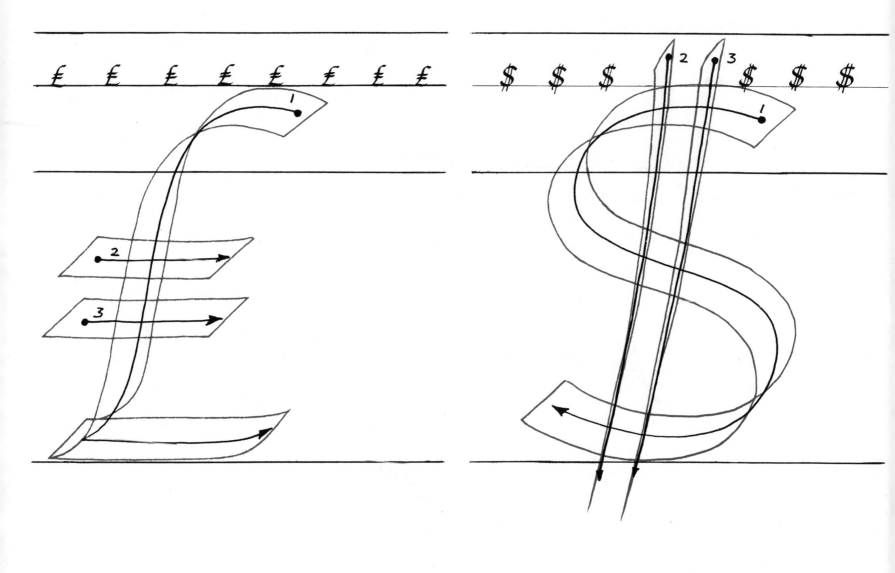

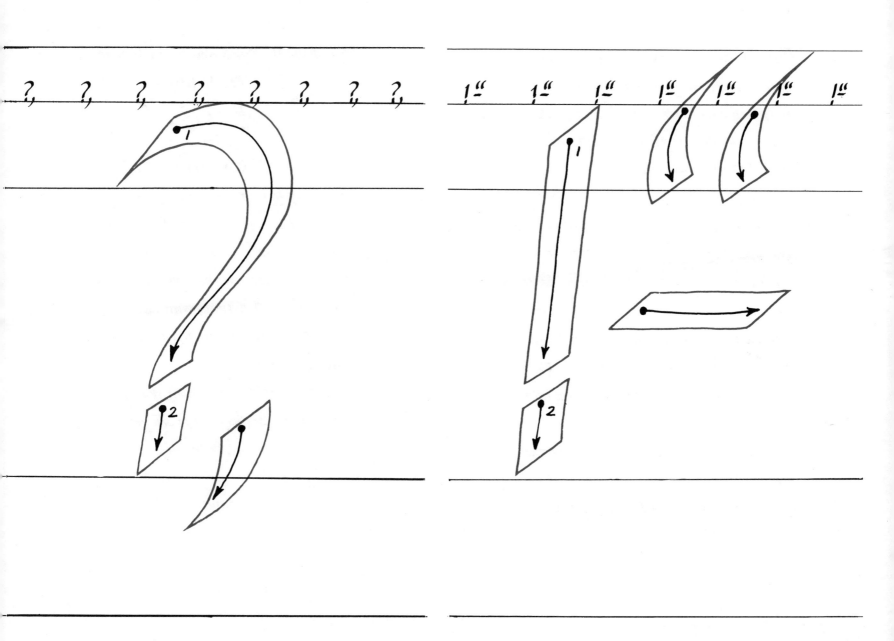

The following pages show simple layouts which can be used for letters and envelopes, recipes, diaries, cards and so on. Stick to these suggestions at first, but later on you should experiment with layouts of your own.

For posters on a larger scale you will need to get much larger pens, called poster pens and witch pens. To avoid wasting paper, pencil in the words very lightly first, and write freely over the top. Never use more than three sizes of pen on the same page, or three colours. Black on its own may provide all the contrast you need.

All you need for this book is one cheap italic pen, medium italic size, and scrap writing paper. Ordinary ink will serve, but black is best.

Achnasheen, Braid Road, Auchterderran,
Perthshire
12 · 12 · 96

Dear Morag

It was lovely to hear from you again, and to know that you will be home for Christmas! Do phone as soon as you land, and we can arrange to meet. We hope you can spend at least part of Christmas with us.
Duncan is staying with us over the holidays, so you'll see him too.
The children are delighted with the presents, and of course are longing to see you.
Love from all!

Anne

Alister Macdonald Finlay

151 Schiehallion Avenue

ABERDEEN

Scotland

Alister Macdonald Finlay

151 Schiehallion Avenue

Aberdeen

SCOTLAND

Mr and Mrs A B Mackenzie

invite you

to attend the wedding of their daughter

Elizabeth

and

Donald Burns Menzies

at

Auld St. Bride's Kirk

on

Friday, twentythird June

at noon

*

Reception afterwards in the Boat Hotel

R·S·V·P

Merry
Christmas
and
a
Happy
New
Year!

from
Mac and Moira

Mary & John Cameron
invite you to attend the opening of their new
Gallery in the High Street, Dunaber, by
Sir Neil Macleod
on Saturday 12 June, at 2.30 pm
*

Paintings · Pottery · Prints · Sculpture
*

January 3 : Menton

Walked to Roquebrune in the morning after
handing my bike in for repairs. Very cold, but
did a passable watercolour. The village is built
on a conglomerate rock, and where it's hewn to
make a path, looks like built rubble.

January 4 : Castellar

In spite of the dull weather, cycled up to
Castellar, finding the clouds nearer and nearer
all the way. Rain prevented sketching.

January 5 : Monaco

Found the famous Aquarium closed, so
went on to visit the old fort. Later I found
the coast road at Monte Carlo was being
deluged with spray from the heavy seas.
After my visit to Cap Martin, I decided
to return by the shorter Route Nationale.

Oatmeal Biscuits

10 oz oatmeal : 10 oz flour : 4oz butter :
4 oz sugar : 1 egg : 1 teaspoon baking soda :
milk : salt.

RUB the butter into the oatmeal and the
flour. Add the sugar, baking soda and
salt. Beat the egg and add with enough
milk to make a stiff dough. Roll out thinly
and cut into rounds. Bake until crisp
in a moderate oven.

Blackcurrant Jam

4 lbs blackcurrants : 8 lbs sugar : 8 cups

ROMAN capitals, ancestor of all these scripts, and itself the flower of thousands of years development

uncial
Many early books were written in uncial scripts

quam — 5th century Roman
zehab — 8th century Irish
ergo — 7th century English

round hand
The model for most of our modern type faces

omnium — 8th century Carolingian
miseran — 15th century Humanistic
script — 20th century [Edward Johnston]

black letter
Decorative, but illegible in many of its varieties

rapidem — 15th century French
aluares — 15th century Spanish
baptiza — 15th century Gothic

italic
Now adopted by many people as everyday writing

dirimpetto — 18th century Italian
quessa parte — 16th century Italian
hombre — 16th century Spanish

How to make your own pens!

(Bamboo, reed, almost any kind of pencil-sized twig can be made into a usable pen. They can be used green, but for a long lasting pen they are best seasoned for six months or more in a dry place.

The hollow bamboo or reed is best, but solid twigs are almost as good. Quills are not quite so easy to prepare, and are best avoided at this stage.

If you find it difficult to cut a straight slice as in ①, do it roughly, then rub down smooth and straight on fine sandpaper, stuck down on a flat surface. This method can also be used to finish the writing edge of the tip.

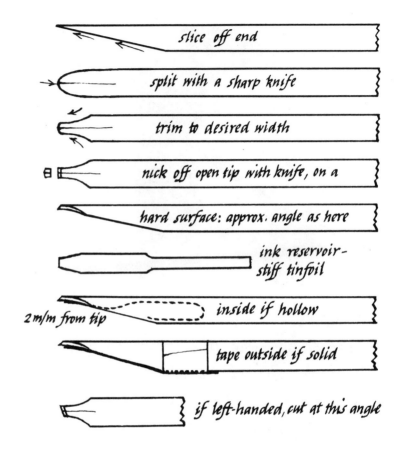

slice off end

split with a sharp knife

trim to desired width

nick off open tip with knife, on a

hard surface: approx. angle as here

ink reservoir- stiff tinfoil

2 m/m from tip inside if hollow

tape outside if solid

if left-handed, cut at this angle

These are some of the materials which can be used to make pens. The harder ones may last for years. The very soft, like the strip of card used to write the "a" above, may only serve for one poster. (Bamboo and reed are most durable, but all can be re-sharpened and used again, until too short to hold.

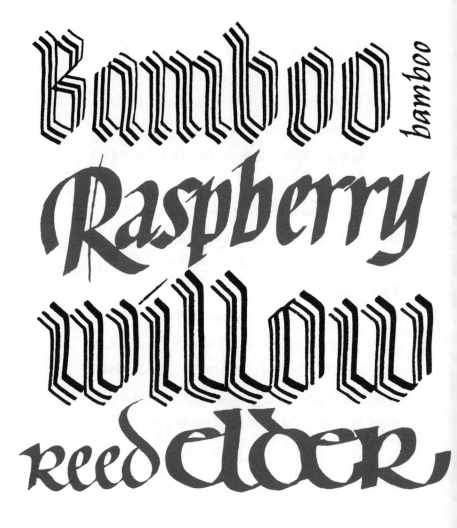

Bamboo *bamboo*
Raspberry
willow
reed elder

Making large poster pens

Here are two ways of making pens to any size you choose. For lettering six inches high, the width of the tip would have to be around one inch.

A slip of almost any straight grained wood will do. Not too thick, and not too thin and flexible; say two m/m.

The tip, cut or sandpapered, should be flat and straight, so ALL its width is in contact with the writing surface.

Note that the thin stroke of the felt pen will depend on the thickness of the felt.

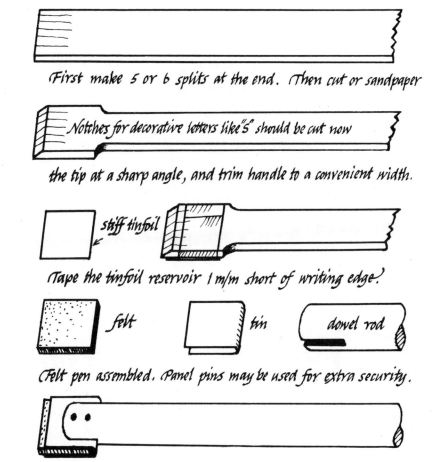

First make 5 or 6 splits at the end. Then cut or sandpaper

Notches for decorative letters like "S" should be cut now

the tip at a sharp angle, and trim handle to a convenient width.

stiff tinfoil

Tape the tinfoil reservoir 1 m/m short of writing edge.

felt tin dowel rod

Felt pen assembled. Panel pins may be used for extra security.

Guide lines are permissible for the learner, to help keep the body of the script an even height, with its ascenders and descenders.

As you become more skilled, all guide lines except the base line may be discarded. This permits a more lively appearance than script written between "tramlines", which tend to look as though they were in a strait jacket.

Many scribes of old preferred to write BETWEEN the lines, which were scored into the surface of the vellum with a blunt point.

Lines may be dispensed with altogether by using a thin writing paper placed over a template – a sheet of paper with black lines already ruled in. These will show through well enough to serve as a guide.

Approximate guide lines: use half, one or two or more

Suitable for Mitchell's Round Hand pen Nº 1, or similar size